# Women Artists

## The National Museum of Women in the Arts

Susan Fisher Sterling

A TINY FOLIO™
Abbeville Press Publishers
New York London Paris

Front cover: Detail of Frida Kahlo, *Self-Portrait Dedicated to Leon Trotsky*, 1937. See page 184.

Back cover: Mary Cassatt, *The Bath*, 1891. See page 102.

Spine: Abastenia Saint Eberle, *Untitled*, n.d. See page 128.

Frontispiece: Detail of Elisabeth-Louise Vigée-Lebrun, *Portrait of Princess Belozersky*, 1798. See page 59.

Page 6: Exterior of The National Museum of Women in the Arts, Washington, D.C.

Page 10: Interior of the museum.

Page 14: Detail of Sofonisba Anguissola, *Double Portrait of a Lady and Her Daughter*, n.d. See page 18.

Page 17: Detail of Louise Moillon, *Bowl of Lemons and Oranges on a Box of Wood Shavings and Pomegranates*, n.d. See page 21.

Page 28: Detail of Rachel Ruysch, *Roses, Convolvulus, Poppies, and Other Flowers in an Urn on a Stone Ledge*, c. 1745. See page 41.

Page 42: Detail of Angelica Kauffman, *The Family of the Earl of Gower*, 1772. See page 54.

Page 45: Detail of Charlotte Mercier, *Madeleine de la Bigotière de Perchambault*, 1757. See page 50.

Page 82: Detail of Rosa Bonheur, *Sheep by the Sea*, 1869. See page 92.

Page 118: Detail of Suzanne Valadon, *The Abandoned Doll*, 1921. See page 146.

Page 192: Detail of Alma Thomas, *Iris, Tulips, Jonquils, and Crocuses*, 1969. See page 240.

Page 248: Detail of Audrey Flack, *Rolls Royce Lady*, 1983. See page 279.

For copyright and Cataloging-in-Publication Data, see page 319.

# CONTENTS

*Introduction*                                    7

THE RENAISSANCE AND BAROQUE WOMAN                15

DUTCH AND FLEMISH PAINTING                       29

THE EIGHTEENTH CENTURY                           43

THE NINETEENTH CENTURY                           83

THE EARLY TWENTIETH CENTURY                     119

THE POSTWAR ERA                                 193

THE 1970S TO THE 1990S                          249

*Index of Credits*                              311

*Index of Illustrations*                        313

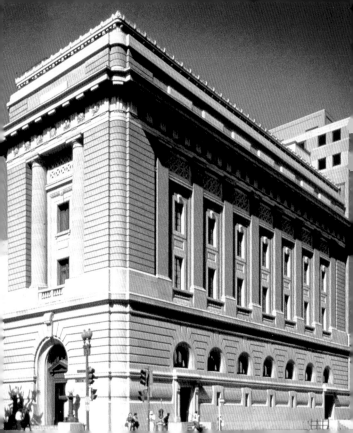

# INTRODUCTION

Someone, I say, will remember us in the future.

*Sappho, 640 B.C.*

The history of all times, and of today especially,
teaches that . . . women will be forgotten if they
forget to think about themselves.

*Louise Otto-Peters, 1849*

Women have created art since earliest times. In the
ancient world the Greeks celebrated the artworks of
Aristarete, Eirene, Kalypso, and Thamyris. Iaia of Cyzi-
cus, who lived in Rome around 100 B.C., was famed as a
painter and engraver of ivories whose portraits were val-
ued beyond price.

During the Middle Ages the women of the church,
from Saint Hilda of England (610–680) to Hildegard of
Bingen (1098–1179), achieved renown for their learning,
piety, and power. In the great abbeys they penned Latin
verse, composed devotional music, and created illumi-
nated manuscripts, vestments, and other precious objects
for both church and state. Noblewomen, too, gained
fame for their achievements as embroiderers and fine

artisans. The Bayeux tapestry—the famous depiction of William the Conqueror's victory at the Battle of Hastings in 1066—is but one of many works created by women of the medieval court. Scores of ancient and medieval artists remain unknown, and in many instances it may be true that "anonymous was a woman."

This volume of works from The National Museum of Women in the Arts (NMWA)—the only museum in the world dedicated to recognizing the achievements of women artists—is a record of women's accomplishments from the Renaissance to the present. Paging through the collection, one experiences a revised history of art. Many of the artists represented in this Tiny Folio may not be known to you, and you will be tempted to ask why you have never heard of them. The answers to that question have much to do with how women have been viewed and valued throughout the history of Western society.

In 1893, at the opening of the magnificent Women's Building at the World's Columbian Exposition, Mrs. Potter Palmer and her Board of Lady Managers expressed the hope that their greatly prized, if temporary, building—dedicated to art, education, home, charity, science, and every branch of human endeavor—would spur the creation of a permanent Woman's Memorial Building. Although this was not to be, one hundred years later that

dream is being realized at The National Museum of Women in the Arts. The museum has the unique mission of bringing "recognition to the achievements of women artists of all periods and nationalities by exhibiting, preserving, acquiring, and researching art by women and by educating the public concerning their achievements." The museum fulfills this mandate by maintaining and displaying a permanent collection, presenting special exhibitions and performances, conducting educational programs, supporting a Library and Research Center, and serving a network of national and international chapters.

The National Museum of Women in the Arts became a reality through the dedication of Wilhelmina Cole Holladay, with the help of countless individuals and organizations across the country. As collectors, Wilhelmina Cole Holladay and Wallace F. Holladay began to focus on art by women during the 1960s, when scholars were just beginning to uncover the rich and varied aspects of that cultural heritage. From the 1960s through the mid-1980s the Holladays assembled a core collection of over three hundred significant works by women artists.

In 1981 The National Museum of Women in the Arts was incorporated as a private, nonprofit institution. At the beginning it was a "museum without walls," offering docent-led tours of the collection at the Holladay residence. Then, in 1983, the museum purchased a

landmark building—formerly the Masonic Temple of the Grand Lodge of the District of Columbia—a few blocks from the White House in Washington. After four years of renovation, the museum opened to the public in the spring of 1987. The groundbreaking inaugural exhibition, *American Women Artists, 1830–1930,* demonstrated the contributions that women from Sarah Miriam Peale to Georgia O'Keeffe had made to the history of American art. It was at this time that the Holladays presented the majority of their collection as a seed donation to the museum. Many of the works from this core collection are reproduced within the pages of this volume, along with several works on loan to the museum from the Holladay collection.

Just one year earlier, in 1986, women artists had been included for the very first time in H. W. Janson's *History of Art,* the standard textbook that has been used by generations of art history students. Women had at last been made part of the canon, although still in very small numbers: of the twenty-three hundred artists discussed in that massive tome, only nineteen were women. Conditions have improved since then, strengthened in part by the presence of the NMWA, along with the burgeoning of feminist scholarship, greater opportunities for contemporary women artists in the marketplace, and a higher concentration of female professors and curators.

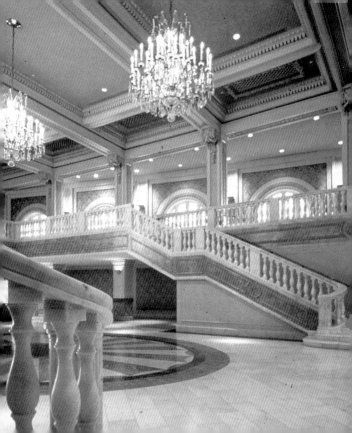

Earlier artists such as Elisabeth-Louise Vigée-Lebrun, Mary Cassatt, Camille Claudel, Frida Kahlo, and Georgia O'Keeffe have been the subject of major retrospectives, here and elsewhere. Contemporary artists—among them Helen Frankenthaler, Eva Hesse, Elizabeth Murray, Louise Nevelson, and Miriam Schapiro—have received significant attention as well. Women artists once were given exhibitions only late in life or posthumously, but now public recognition tends to come earlier. Still, there is much to be done.

Since its opening, The National Museum of Women in the Arts has acquired important works of art by Sofonisba Anguissola, Judith Leyster, Elisabeth-Louise Vigée-Lebrun, Lilly Martin Spencer, Käthe Kollwitz, Frida Kahlo, Louise Dahl-Wolfe, Louise Nevelson, Dorothy Dehner, and many others; it has also received collections of Georgian silver by British silversmiths, miniatures on ivory by Eulabee Dix, and engravings by Grace Albee. The permanent collection now comprises well over twelve hundred paintings, drawings, prints, photographs, sculptures, ceramics, and other decorative objects. The museum also has created a Library and Research Center well known for its resources on women in the arts, including a fine collection of artists' books and archival materials on over fifteen thousand women artists. As the museum has grown, so has the range of its activities. In

1987 the museum commissioned an inaugural musical work by the Pulitzer Prize–winning composer Ellen Taaffe Zwilich. Since then works by women composers, musicians, poets, playwrights, actors, choreographers, dancers, architects, and designers have been highlighted and documented by the museum's programs.

Noteworthy as well is the museum's grass-roots support. Since its inauguration, over 125,000 people have joined the NMWA, making it the third-largest museum in the United States in terms of membership. In response to this outpouring of interest, the museum has established a national network of state chapters, whose purpose is to offer state-level educational events, research programs, and exhibitions and to assist in the accumulation of resource materials for the Library and Research Center. There are currently eighteen chapters, with several more in formation.

The National Museum of Women in the Arts strives to integrate women into the historical mainstream of artistic achievement and to foster the visibility of contemporary women artists working in diverse disciplines. The more we know about women of the past and the more we work together to recognize women of the present, the greater will be the legacy for future generations to cherish.

# THE RENAISSANCE AND BAROQUE WOMAN

> If it were customary to send little girls to school
> and teach them the same subjects as are taught to
> boys, they would learn just as fully and would
> understand the subtleties of all arts and sciences.
>
> *Christine de Pisan*,
> Cité des dames, *1405*

The Renaissance philosophy of humanism did much to redefine the concept of man and, to a lesser extent, woman. Seeking to merge the ideals of ancient Greece and Rome with those of Christianity, the humanists endowed the individual with renewed importance, and education became a path to virtue. For aristocratic and middle-class women, schooling became an essential component of their upbringing for the first time. Although they usually received less rigorous instruction than their male counterparts, exceptional women were able to secure impressive liberties. Taking full advantage of privilege and opportunity, Isabella d'Este established herself as a humanist patron par excellence; Isabella I, queen of Castile and Aragon, financed Columbus's voyages and consolidated Catholic Spain; and Elizabeth I ruled England astutely and absolutely for almost fifty years.

In the arts, humanism advanced a new definition of the artist-genius, whose workshop was the center of creative production. It was generally believed that females were incapable of genius, but those who did become artists often developed in a milieu that appreciated their talents and ambitions. They were frequently daughters of successful artists and worked in their fathers' studios, as did the Bolognese painter Lavinia Fontana. Occasionally they were members of the nobility, like Sofonisba Anguissola, who is considered to have been the first woman artist of the Renaissance. Born into an aristocratic family, Anguissola was the first woman artist to achieve international renown as a portrait painter, triumphing first in Italy and later becoming court painter to Philip II of Spain. Aware of her novelty as a woman artist and confident of her abilities to render likenesses accurately, she created numerous self-portraits at a time when relatively few other artists did so.

Anguissola's *Double Portrait of a Lady and Her Daughter* (page 18) and Fontana's slightly later *Portrait of a Noblewoman* (page 19) tell us much about aristocratic attitudes of the day. In both, the woman's gaze is averted, the clothing and jewelry are lavish, and a dog or child accompanies the subject. Both sitters embody the virtues of modesty, propriety, and fidelity that exemplified a noblewoman's role as her husband's property and helpmate.

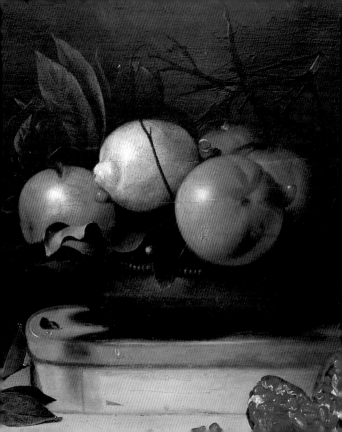

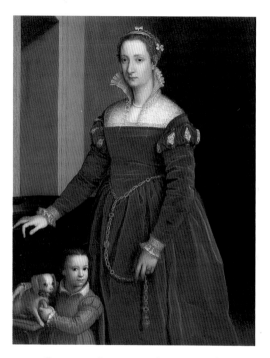

SOFONISBA ANGUISSOLA (c. 1532–1625).
*Double Portrait of a Lady and Her Daughter,* n.d.
Oil on canvas, 52 x 39½ in. (132 x 100.3 cm).

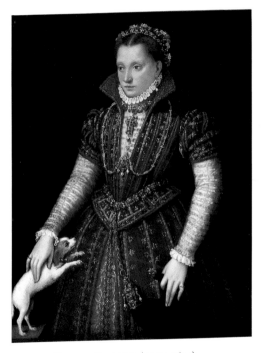

LAVINIA FONTANA (1552–1614).
*Portrait of a Noblewoman*, c. 1580.
Oil on canvas, 45¼ x 35¼ in. (114.9 x 89.5 cm).

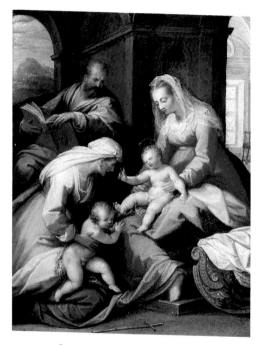

LAVINIA FONTANA (1552–1614).
*Holy Family with Saint John,* n.d.
Oil on metal, 8⅞ x 7⅛ in. (22.5 x 18.1 cm).

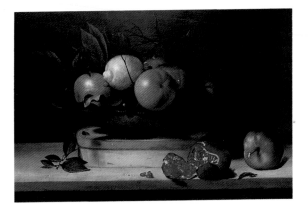

LOUISE MOILLON (1610–1696).
*Bowl of Lemons and Oranges on a Box of Wood Shavings and
Pomegranates,* n.d. Oil on panel, 15¾ x 24½ in. (40 x 62 cm).

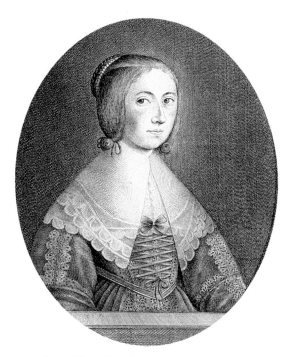

ANNA MARIA VAN SCHURMAN (1607–1678).
*Self-Portrait*, 1640. Engraving, 8 x 5⅞ in. (20.3 x 14.9 cm).

MARY BEALE (1632–1697).
*Portrait of a Woman with a Black Hood*, c. 1660.
Oil on canvas, 28¼ x 23½ in. (71.8 x 59.7 cm).

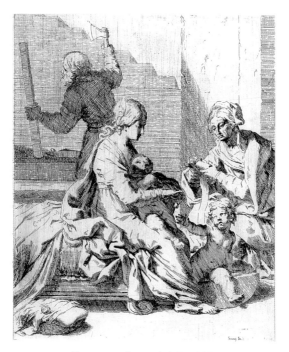

ELISABETTA SIRANI (1638–1665).
*The Holy Family with Saint Elizabeth and Saint John
the Baptist,* n.d. Etching, 10½ x 8½ in. (26.7 x 21.6 cm).

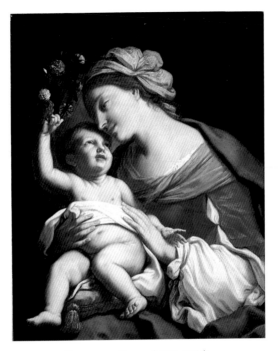

ELISABETTA SIRANI (1638–1665).
*Virgin and Child*, 1663.
Oil on canvas, 34 x 27½ in. (86.4 x 69.9 cm).

Antoinette Bouzonnet-Stella (1641–1676).
*The Entrance of Emperor Sigismond into Mantua,* 1675. No. 17
of twenty-five engravings, 6½ x 15¾ in. (16.5 x 40 cm).

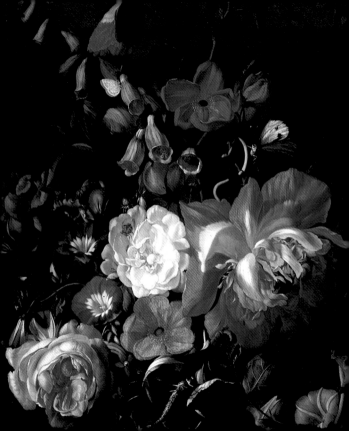

# DUTCH AND FLEMISH PAINTING

Flemish painting . . . will appeal to women,
especially the very old and the very young, and
also to monks and nuns and to certain noblemen
who have no sense of true harmony. In Flanders,
they paint with a view to external exactness . . .
stuffs and masonry, the green grass of fields, the
shadows of trees, and rivers and bridges, which
they call landscapes. . . .

*Attributed to Michelangelo by*
*Francisco da Hollanda, 1548*

Whereas Renaissance and Baroque artists in Italy concentrated on religious subjects, historical scenes, and portraiture, northern painters found great beauty and depth of spirit in the newer forms of still life, genre, and landscape painting. These subjects were considered markedly less important by the great southern artists, who often dismissed them as womanish in character.

This prejudice seems not to have troubled Dutch and Flemish artists, who viewed their paintings as valuable expressions of a new national culture. The objects and activities of daily life became a focus of artistic interest, reflecting the prosperity and well-being of the Dutch

and Flemish burghers. Women like Clara Peeters excelled at such subjects and were among the pioneers of the new style of still-life painting (page 32). Judith Leyster, an exceptional painter, was much admired for genre scenes in which she portrayed psychological interactions with uncommon intensity (page 33).

Remarkable as well was the German-born Maria Sibylla Merian, whose hand-colored engravings are as important to the history of science as they are to the history of art (pages 34–39). In 1699, with the support of the city of Amsterdam, she embarked upon a grueling journey to the Dutch colony of Surinam in South America, spending two years compiling a study of insect life-cycles and habitats there. After she returned to Holland, her vividly descriptive and scientifically accurate engravings documenting her research were published in 1705. The National Museum of Women in the Arts is fortunate in owning a complete volume of the 1719 posthumous edition of her *Dissertation in Insect Generations and Metamorphosis in Surinam*.

Although art created from the studious observation of real life may have lacked the grand manner of other commissions, these women could achieve profundity in such work. This was certainly true of Rachel Ruysch, the last of the great Dutch still-life painters. The daughter of a distinguished professor of anatomy and botany,

she, like Merian, pursued uncompromising scientific realism in her paintings. Ruysch often included strange new flora and fauna from the Dutch trading voyages in her work, as well as new varieties of flowers, fruits, and insect life (pages 40 and 41). Using flowers to demonstrate the cycles of birth, life, death, and decay, her paintings offer hidden messages about morality and mortality that were much appreciated by her contemporaries.

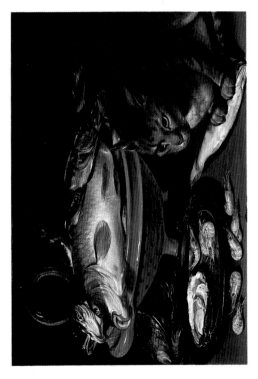

CLARA PEETERS (1594–1657).
*Still Life of Fish and Cat*, n.d. Oil on panel, 13½ x 18½ in. (34.3 x 47 cm).

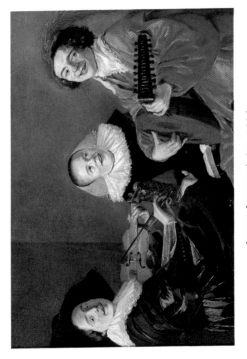

JUDITH LEYSTER (1609–1660).
*The Concert*, c. 1631–33. Oil on canvas, 24 x 34¼ in. (61 x 87 cm).

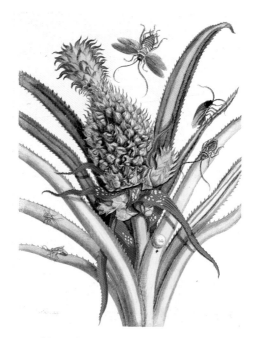

MARIA SIBYLLA MERIAN (1647–1717).
Plate 2 from *Dissertation in Insect Generations and Metamorphosis in Surinam*, second edition, 1719. Hand-colored engraving, approximately 12¾ x 9¾ in. (32.4 x 24.8 cm).

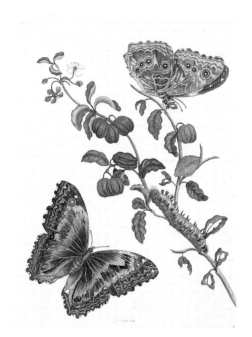

MARIA SIBYLLA MERIAN (1647–1717).
Plate 7 from *Dissertation in Insect Generations and Metamorphosis in Surinam,* second edition, 1719. Hand-colored engraving, approximately 12¾ x 9¾ in. (32.4 x 24.8 cm).

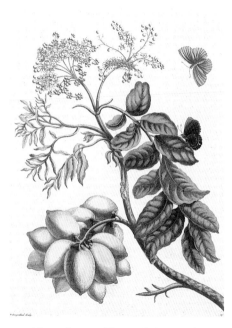

Maria Sibylla Merian (1647–1717).
Plate 13 from *Dissertation in Insect Generations and Metamorphosis in Surinam,* second edition, 1719. Hand-colored engraving, approximately 12¾ x 9¾ in. (32.4 x 24.8 cm).

MARIA SIBYLLA MERIAN (1647–1717).
Plate 31 from *Dissertation in Insect Generations and Metamorphosis in Surinam*, second edition, 1719. Hand-colored engraving, approximately 12¾ x 9¾ in. (32.4 x 24.8 cm).

MARIA SIBYLLA MERIAN (1647–1717).
Plate 37 from *Dissertation in Insect Generations and Metamorphosis in Surinam,* second edition, 1719. Hand-colored engraving, approximately 12¾ x 9¾ in. (32.4 x 24.8 cm).

Maria Sibylla Merian (1647–1717).
Plate 69 from *Dissertation in Insect Generations and Metamorphosis
in Surinam,* second edition, 1719. Hand-colored engraving,
approximately 12¾ x 9¾ in. (32.4 x 24.8 cm).

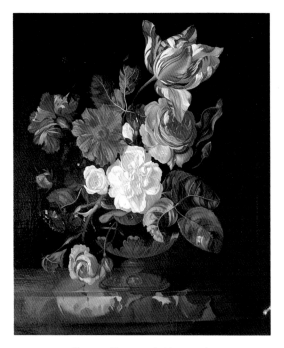

RACHEL RUYSCH (1664–1750).
*Flowers in a Vase*, n.d.
Oil on canvas, 18¾ x 15¾ in. (47.6 x 40 cm).

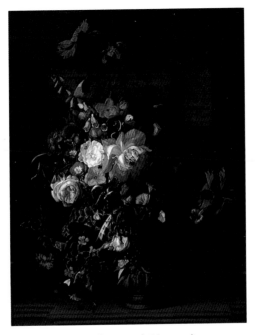

RACHEL RUYSCH (1664–1750).
*Roses, Convolvulus, Poppies, and Other Flowers in an*
*Urn on a Stone Ledge*, c. 1745. Oil on canvas,
42½ x 33 in. (108 x 84 cm).

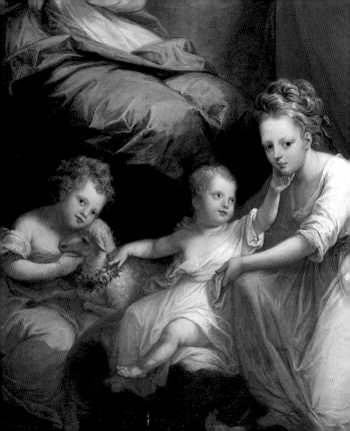

# THE EIGHTEENTH CENTURY

Woman was the governing principle, the direct-
ing reason and the commanding voice of the
18th century. . . . She held the revolutions of
alliances and political systems, peace and war, the
literature, the arts and the fashions of the eigh-
teenth century, as well as its destinies, in the folds
of her gown.

*Edmond and Jules de Goncourt,* 1862

The eighteenth century in France—the Age of Abso-
lutism and the Age of Reason—has also been called the
"feminine age." For one brief period in French history,
when the last of the Bourbon line reigned over the royal
court at Versailles, women held court in the salons of
Paris. *Salonnières* such as Madame Geoffrin, Madame de
La Fayette, and Madame de Staël hosted evenings of cul-
tivated conversation that were attended by the leading
philosophers, writers, artists, and scientists of their day.

At a time when a premium was placed on courtly
charm and women served as muse, one exceptionally
successful *salonnière,* the painter Elisabeth-Louise Vigée-
Lebrun, used these attitudes to her own advantage. Pos-
sessed of the remarkable ability to render all who came

43

before her in a highly flattering manner (pages 59–62), in 1779 she became court painter to Marie Antoinette, whose portrait she painted more than twenty times. Vigée-Lebrun's flattering portrayals of the aristocracy often are viewed as proof of the superficiality of life at court and the disintegrating social order. It is ironic that, like the unpopular and ill-fated Marie Antoinette, many successful women of this era became targets for the anger felt toward the excesses of the men who wielded power.

Eighteenth-century women were not offered the same kind of training as men: they could not study at the Ecole des Beaux-Arts or draw from the nude model; they were prohibited from competing for the prestigious Prix de Rome. Not until Jacques-Louis David opened the Louvre's royal collection to the public were women able to study the art of the past. In 1784, less than one year after Vigée-Lebrun and Adélaïde Labille-Guiard were reluctantly accepted into the Académie des Beaux-Arts, a resolution was passed that no more than four women could be members at any one time.

Compared to her counterparts in France, the Swiss-born Angelica Kauffman was equally well known but ultimately more fortunate. A founder of the Royal Academy in London in 1768, she boldly stepped outside the feminine norms of portraiture and still-life painting to produce history paintings. In fact, she is credited with

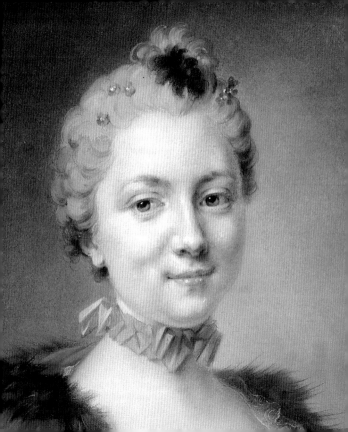

introducing this most highly valued category of painting to English art. Kauffman's *Family of the Earl of Gower* (page 54) provides a glimpse into how the artist reconciled her desire to create history painting with the opportunities available to her as a professional artist in England. By dressing the earl and his family in classical garb, portraying them in stock historical poses, and surrounding them with Neoclassical props, she transformed what could have been a straightforward group portrait into an allegorical tableau.

Many of the Neoclassical motifs that appeared in the art of the eighteenth century—drapery swags, urns, acanthus leaves—also were incorporated into the silver designs of the period. During the eighteenth century, major social and economic changes in England led to an enormous expansion of the silver trades and to the rise of women to positions of prominence as silver designers and manufacturers. Some of the outstanding silversmiths of the Georgian era included Hester Bateman and Rebecca Emes (two of the period's silversmiths who were most successful in adapting the latest technological advances to the production of silver); Elizabeth Godfrey and Louisa Courtauld, whose works capture the elaborateness of French design; and Magdalen Feline, one of the many women silversmiths who created exquisite tea services.

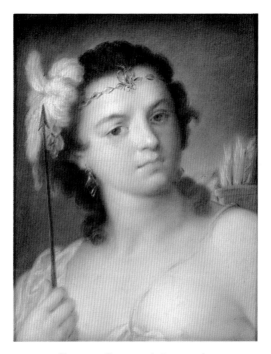

ROSALBA CARRIERA (1675–1757).
*America*, c. 1730. Pastel on paper mounted on canvas,
16½ x 13 in. (41.9 x 33 cm).

MARIANNE LOIR (1715–1769).
*Presumed Portrait of Madame Geoffrin,* n.d.
Oil on canvas, 39½ x 32¼ in. (100.3 x 81.9 cm).

ANNA DOROTHEA LISIEWSKA-THERBUSCH (1721–1782).
*Woman with a Veil*, n.d.
Pastel on paper, 23¼ x 19½ in. (59 x 49.5 cm).

49

CHARLOTTE MERCIER (1738–1762).
*Madeleine de la Bigotière de Perchambault,* 1757.
Pastel on board, 23⅞ x 19¼ in. (60.6 x 48.9 cm).

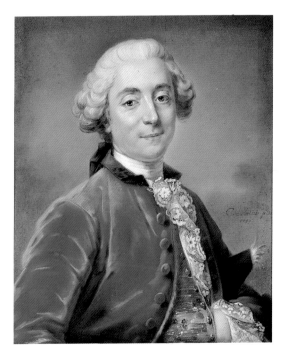

CHARLOTTE MERCIER (1738–1762).
*Oliver le Gouidic de Troyon,* 1757.
Pastel on board, 23⅞ x 19¼ in. (60.6 x 48.9 cm).

ANGELICA KAUFFMAN (1741–1807).
*A Bust of a Girl with an Earring*, 1770.
Etching, 5 x 3¾ in. (12.7 x 9.5 cm).

ANGELICA KAUFFMAN (1741–1807).
*A Bust of a Girl with a Rose in Her Hair*, 1768.
Etching, 5¹⁄₁₆ x 3⅞ in. (12.9 x 9.8 cm).

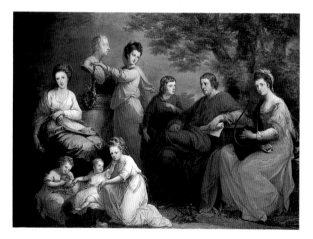

ANGELICA KAUFFMAN (1741–1807).
*The Family of the Earl of Gower*, 1772.
Oil on canvas, 59¼ x 82 in. (150.5 x 208.3 cm).

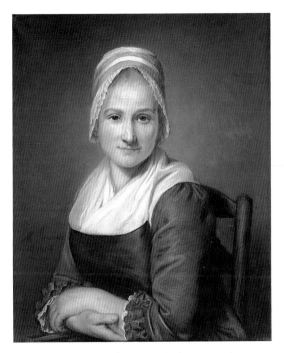

MARIE-GENEVIÈVE NAVARRE (1737–1795).
*Portrait of a Young Woman,* 1774.
Pastel on paper, 24 x 19¾ in. (61 x 50.2 cm).

LADY DIANA BEAUCLERK (1734–1808).
*Love in Bondage,* c. 1795.
Watercolor on paper, 16½ x 20½ in. (41.9 x 52.1 cm).

ADÉLAÏDE LABILLE-GUIARD (1749–1803).
*Presumed Portrait of the Marquise de Lafayette,* n.d.
Oil on canvas, 30¾ x 24¾ in. (78.1 x 62.9 cm).

ADÈLE ROMANY (1769–1846).
*Portrait of Madame Louise Vigée,* n.d.
Oil on canvas, 35½ x 27½ in. (90 x 70 cm).

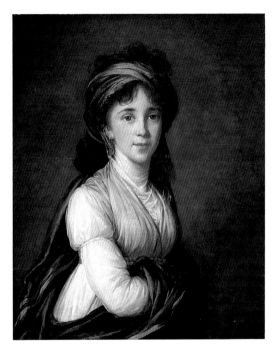

ELISABETH-LOUISE VIGÉE-LEBRUN (1755–1842).
*Portrait of Princess Belozersky,* 1798.
Oil on canvas, 31 x 26¼ in. (78.7 x 66.7 cm).

ELISABETH-LOUISE VIGÉE-LEBRUN (1755–1842).
*Monsieur de Solticoff*, from *Sketchbook Comprising Thirty-eight Portrait
Drawings of Women and Children of the Russian Court*, c. 1801.
Graphite and chalk on paper, 7 x 4⅜ in. (17.8 x 11.1 cm).

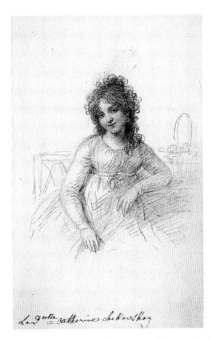

ELISABETH-LOUISE VIGÉE-LEBRUN (1755–1842).
*Princess Catherine Chikovskoy*, from *Sketchbook Comprising Thirty-eight Portrait Drawings of Women and Children of the Russian Court*,
c. 1801. Graphite and chalk on paper, 7 x 4⅜ in. (17.8 x 11.1 cm).

ELISABETH-LOUISE VIGÉE-LEBRUN (1755–1842).
*Portrait of a Young Boy,* 1817.
Oil on canvas, 21¾ x 18¼ in. (55.2 x 46.4 cm).

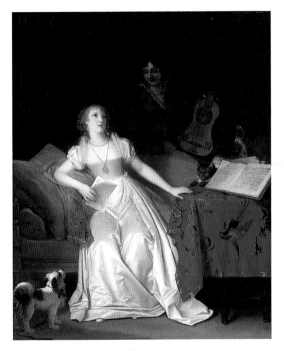

Marguerite Gérard (1761–1837).
*Prelude to a Concert*, c. 1810.
Oil on canvas, 22¼ x 18¾ in. (56.5 x 47.6 cm).

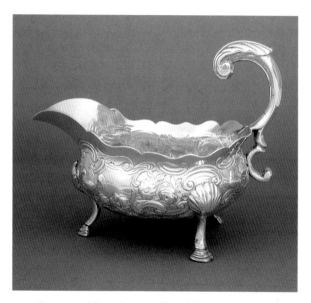

DOROTHY MILLS (c. 1716–?) and THOMAS SARBITT.
*George II Sauce Boat,* 1748.
Silver, 4¾ x 5¼ x 3⅞ in. (12.1 x 13.3 x 9.8 cm).

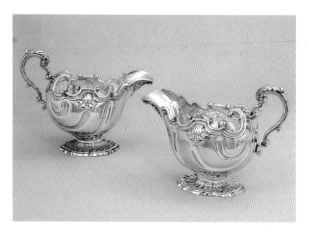

ELIZABETH GODFREY (c. 1700–?).
*Pair of George II Sauce Boats,* 1750.
Silver, 6⅛ x 8¼ x 4⅜ in. (15.6 x 21 x 11.1 cm), each.

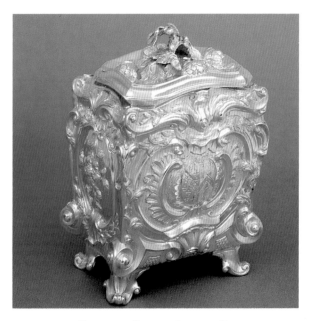

ELIZABETH GODFREY (c. 1700–?).
*George II Tea Caddy, 1755.*
Silver, 5¾ x 4⅜ x 3⅜ in. (14.6 x 11.1 x 8.6 cm).

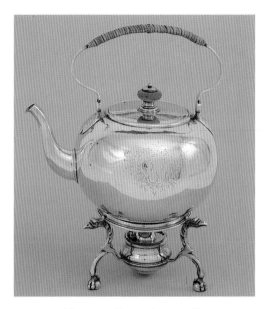

MAGDALEN FELINE (c. 1733–?).
*George II Kettle on Stand,* 1756.
Silver, with wicker-wrapped handle and wood finial,
9½ x 7¼ x 5¼ in. (24.1 x 18.4 x 13.3 cm).

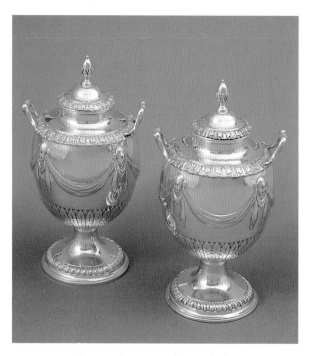

LOUISA COURTAULD (1729–1807).
*Pair of George III Tea Caddies*, 1766.
Silver, 7⅜ x 4⅛ x 4 in. (18.7 x 10.5 x 10.2 cm).

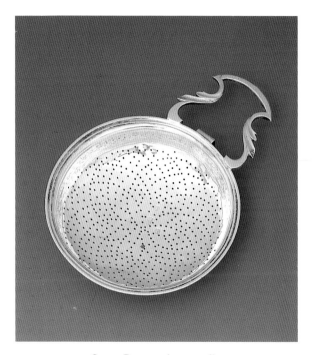

SARAH BUTTALL (c. 1734–?).
*George III Lemon Strainer*, 1771.
Silver, ⅞ x 5¾ x 4⅛ in. (2.2 x 14.6 x 10.5 cm).

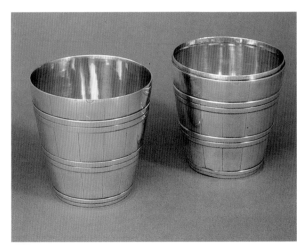

HESTER BATEMAN (1708–1794).
*George III Double Beaker,* 1790.
Silver, 6 x 3 x 3 in. (15.2 x 7.6 x 7.6 cm).

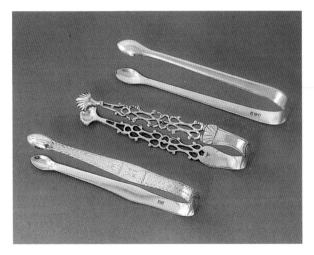

HESTER BATEMAN (1708–1794), ANN BATEMAN (1749–1815),
PETER BATEMAN, and WILLIAM BATEMAN. *George III Sugar
Tongs,* late 18th or early 19th century. Silver, top: 5⅜ x 1⅞ x
½ in. (14.3 x 4.7 x 1.3 cm); center: 5⅜ x 1¼ x ⅝ in. (13.7 x
3.2 x 1.6 cm); bottom: 5⅜ x 1⅝ x ½ in. (13.7 x 4.1 x 1.3 cm).

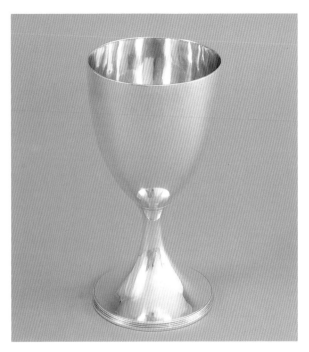

ANN BATEMAN (1749–1815) and PETER BATEMAN.
*George III Goblet,* 1797.
Silver, 6 x 3 x 3 in. (15.2 x 7.6 x 7.6 cm).

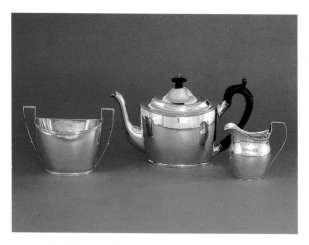

ANN BATEMAN (1749–1815), PETER BATEMAN, and
WILLIAM BATEMAN. *George III Tea Set,* 1800. Silver, sugar bowl:
4¾ x 6¾ in. (12.1 x 17.1 cm); teapot: 7 x 12 x 4½ in. (17.8 x 30.5
x 11.4 cm); creamer: 4 x 4¾ x 2¼ in. (10.2 x 12.1 x 5.7 cm).

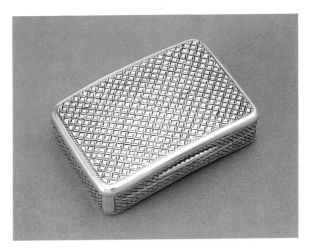

ALICE BURROWS (c. 1776–?).
*George III Snuff Box*, 1802.
Silver, ¾ x 3⅛ x 2⅛ in. (1.9 x 7.9 x 5.4 cm).

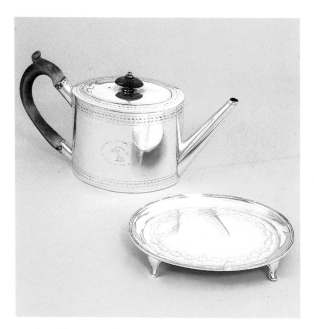

ALICE BURROWS (c. 1776–?) and GEORGE BURROWS II.
*George III Teapot,* 1803. Silver, with wood handle and finial,
5⅛ x 9¼ x 3½ in. (13 x 23.5 x 8.9 cm).
HANNAH NORTHCOTE (c. 1778–?). *George III Teapot Stand,*
1809. Silver, ¾ x 6⅜ x 5 in. (1.9 x 16.2 x 12.7 cm).

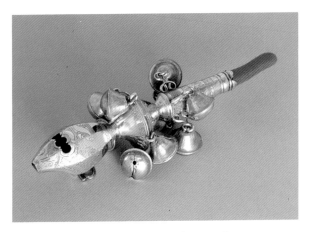

MARY ANN CROSWELL (c. 1775–?).
*George III Child's Rattle,* 1808.
Silver with coral, length: 5⅜ in. (13.7 cm).

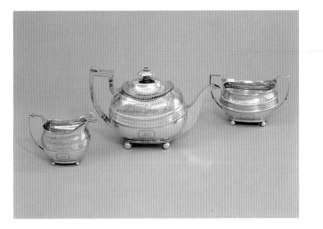

Dorothy Langlands (c. 1783–?).
*George III Tea Set,* 1809–12. Silver, creamer: 3½ x 5⅜ x 2¾ in.
(8.9 x 13.7 x 7 cm); teapot: 6½ x 11 x 6¼ in. (16.5 x 27.9 x
15.9 cm); sugar bowl: 4¼ x 7 x 4⅛ in. (10.8 x 17.8 x 10.5 cm).

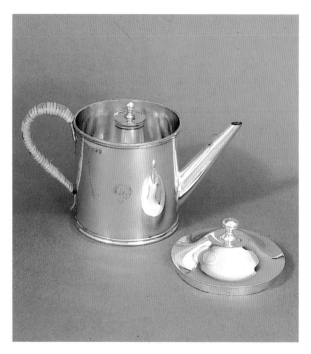

REBECCA EMES (c. 1778–c. 1829) and EDWARD BARNARD.
*Regency Argyll,* 1811. Silver, with wicker-wrapped handle,
4¾ x 7 x 3½ in. (12.1 x 17.8 x 8.9 cm).

REBECCA EMES (c. 1778–c. 1829) and EDWARD BARNARD.
*Regency Goblet*, 1812. Silver,
5 x 3½ x 3½ in. (12.7 x 8.9 x 8.9 cm).

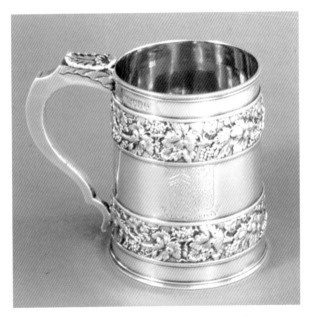

REBECCA EMES (c. 1778–c. 1829) and EDWARD BARNARD.
*Regency Parcel-Gilt Mug*, 1814.
Silver, 4⅜ x 5½ x 3⅛ in. (11.1 x 14 x 7.9 cm).

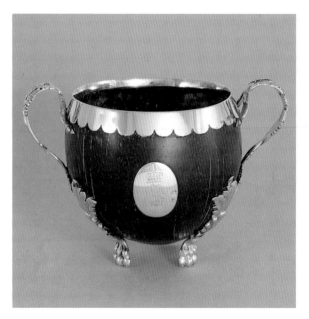

Rebecca Emes (c. 1778–c. 1829) and Edward Barnard.
*George IV Silver-Mounted Two-Handled Coconut Cup*, 1825.
Silver and coconut, 4⅜ x 7 x 4⅝ in. (11.1 x 17.8 x 11.7 cm).

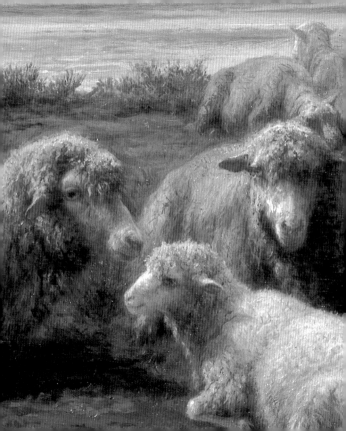

# THE NINETEENTH CENTURY

How many irritations for the single woman! There
are a thousand places where only men are to be
seen, and if she needs to go there on business, the
men are amazed and laugh like fools. . . . Should
she find herself at the other end of Paris and hun-
gry, she will not dare enter a restaurant. She would
constitute an event; she would be a spectacle.

*Jules Michelet, 1858–60*

The nineteenth century ushered in large-scale social
changes affecting the lives of women on both sides of
the Atlantic. Along with the Industrial Revolution, the
rise of the bourgeoisie, and growing support for woman
suffrage and education reforms came the promise of
greater freedom and enfranchisement. At the same time,
however, for women of the new bourgeois class—
whether in Paris or Boston, London or New York—the
restrictive Victorian ideal of womanhood prevailed.

For the woman artist, the growing identification
of women with a purely domestic realm posed some
difficult challenges. Rosa Bonheur, for example, was rec-
ognized and celebrated as the greatest animal painter of
the nineteenth century. While researching her paintings

(page 92) she regularly visited horse fairs, dissected carcasses in slaughterhouses, and observed animals at work in the countryside. To pursue her studies without harassment and to avoid the dangers that a lone woman risked encountering in a public place, she felt obliged to dress in men's clothing—a practice that required legal authorization.

With increasing emphasis on maternal bliss and feminine accomplishment as the nineteenth century progressed, many American women artists came to view domesticity as a proper subject for their art. As in seventeenth-century Holland and Flanders, the newly prosperous middle class in nineteenth-century America expressed a strong preference for scenes of everyday life. Genre painting dominated the art market, and Lilly Martin Spencer was one of its most acclaimed practitioners. Her intimate portrayals of domestic dramas were extremely popular. *The Artist and Her Family at a Fourth of July Picnic* (page 90), the artist's depiction of her own family's game of blindman's bluff, is one of the finest examples of Spencer's large-scale, multifigure genre scenes.

With the development of Impressionism later in the century, narrative or academic art was rejected in favor of paintings that celebrated light, color, and modern life. Contemporary genre scenes, for example, began to include portrayals of bourgeois family life, as well as scenes

at the theater and in cafés. Within the Impressionist group, Berthe Morisot and Mary Cassatt found a congenial environment that encouraged them to use their own experiences as women for their subject matter. Their art concentrates on objects and scenes of daily life (pages 100 and 101) and on images of young girls, adolescents, and mothers (pages 102–5)—considered a radical theme at the time.

Interest in the domestic sphere influenced portraiture as well. As the boundaries between different categories of painting began to blur, American artists like Cecilia Beaux and Lilla Cabot Perry sought to combine new ideas and techniques learned in Paris with their own personal styles of portraiture. Beaux's expressive brushwork, rich palette, and effective use of relaxed poses for her sitters (page 98) caused her work to be compared frequently to that of John Singer Sargent and the Impressionists. Perry's portraits (pages 106–8) were recognized as demonstrating her ability to merge the lessons of Impressionism with the crisp likenesses typical of the Boston School of painters. Their fusions of French style with their own distinctively American taste provided an important example to other artists of the period and later decades.

ANNA CLAYPOOLE PEALE (1791–1878).
*Nancy Aertsen*, c. 1820.
Watercolor on ivory, 3½ x 2⅞ in. (8.9 x 7.3 cm).

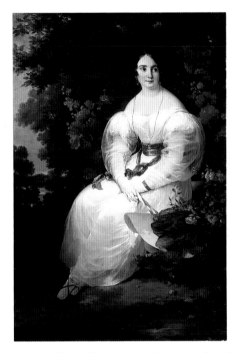

ANTOINETTE-CECILE HAUDEBOURT-LESCOT (1784–1845).
*Young Woman Seated in the Shade of a Tree,* c. 1830.
Oil on canvas, 67 x 45½ in. (170.2 x 115.6 cm).

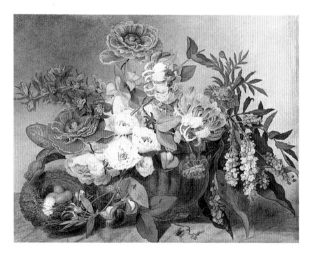

ANNE FRANCES BYRNE (1775–1837).
*Honeysuckle, Poppies, etc.*, n.d.
Watercolor on paper, 13 x 17½ in. (33 x 44.5 cm).

LILLY MARTIN SPENCER (1822–1902).
*Still Life with Watermelon, Pears, and Grapes,* c. 1860.
Oil on canvas, 13⅛ x 17¼ in. (33.3 x 43.8 cm).

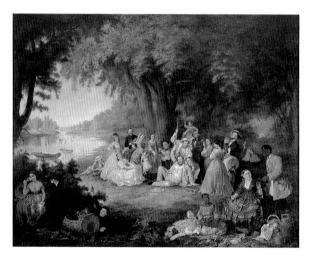

LILLY MARTIN SPENCER (1822–1902).
*The Artist and Her Family at a Fourth of July Picnic,* c. 1864.
Oil on canvas, 49½ x 63 in. (125.7 x 160 cm).

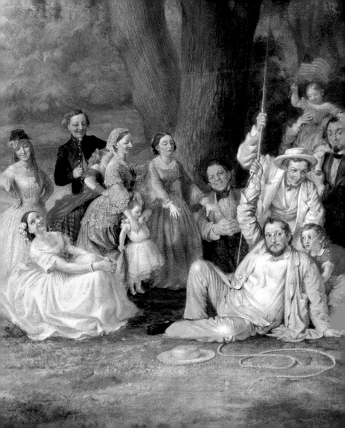

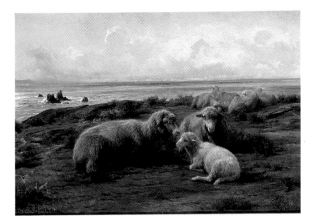

ROSA BONHEUR (1822–1899).
*Sheep by the Sea,* 1869.
Oil on cradled panel, 12¾ x 18 in. (32.4 x 45.7 cm).

ELLEN ROBBINS (1828–1905).
*Marigolds,* 1885.
Watercolor on paper, 16 x 21 in. (40.6 x 53.3 cm).

ELIZABETH GARDNER BOUGUEREAU (1837–1922).
*The Shepherd David Triumphant,* c. 1895.
Oil on canvas, 61½ x 42½ in. (156.2 x 108 cm).

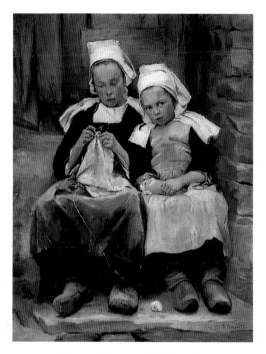

ENELLA BENEDICT (1858–1942).
*Brittany Children,* c. 1892.
Oil on canvas, 31⅜ x 24⅛ in. (80.3 x 61.3 cm).

Jennie Augusta Brownscombe (1850–1936).
*Love's Young Dream*, 1887.
Oil on canvas, 21¼ x 32⅛ in. (54 x 81.6 cm).

JENNIE AUGUSTA BROWNSCOMBE (1850–1936).
*Thanksgiving at Plymouth*, 1925.
Oil on canvas, 30 x 39⅛ in. (76.2 x 99.4 cm).

CECILIA BEAUX (1855–1942).
*Ethel Page (Mrs. James Large),* 1884.
Oil on canvas, 30 x 25⅛ in. (76.2 x 63.8 cm).

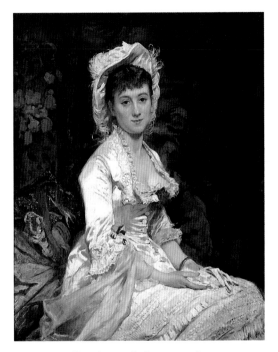

EVA GONZALÈS (1849–1883).
*Portrait of a Woman in White,* 1879.
Oil on canvas, 39½ x 31 in. (100 x 81.2 cm).

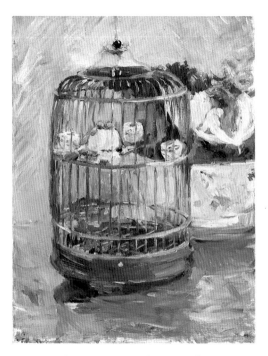

BERTHE MORISOT (1841–1895).
*The Cage,* 1885. Oil on canvas,
19⅞ x 15 in. (50.5 x 38.1 cm).

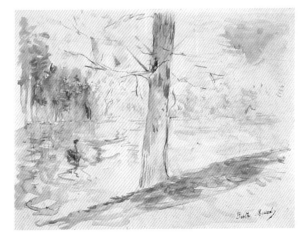

BERTHE MORISOT (1841–1895).
*Lake at Bois de Boulogne*, c. 1887.
Watercolor on paper, 8¾ x 11½ in. (22.2 x 29.2 cm).

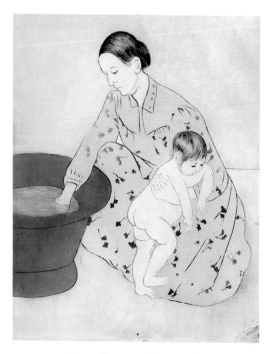

MARY CASSATT (1844–1926).
*The Bath,* 1891. Soft-ground etching with aquatint and
drypoint, 12⅜ x 9⅝ in. (31.4 x 24.4 cm).

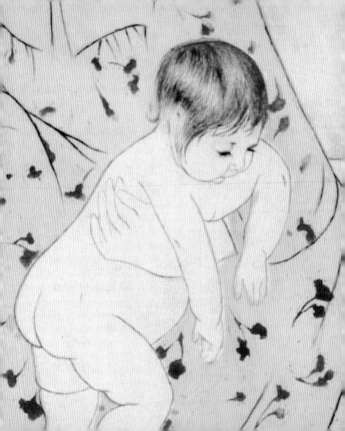

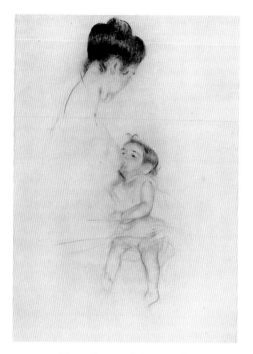

MARY CASSATT (1844–1926).
*Mother Louise Nursing Her Child,* 1899.
Etching with drypoint, 13⅛ x 8⅞ in. (33.3 x 22.5 cm).

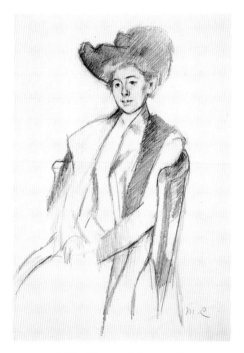

MARY CASSATT (1844–1926).
*Portrait Sketch of Mme. Fontveille, No. 1,* c. 1902.
Pencil on paper, 16¼ x 11½ in. (41.3 x 29.2 cm).

LILLA CABOT PERRY (1848–1933).
*Portrait of Elsa Tudor*, c. 1898.
Oil on canvas, 31½ x 25½ in. (80 x 64.8 cm).

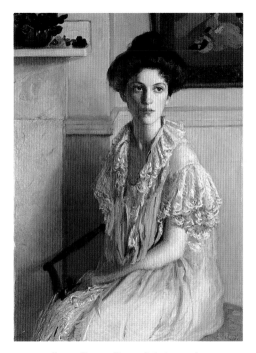

LILLA CABOT PERRY (1848–1933).
*Lady with a Bowl of Violets*, c. 1910.
Oil on canvas, 40¼ x 30 in. (102.2 x 76.2 cm).

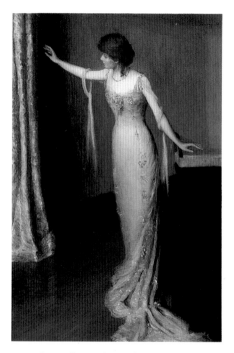

LILLA CABOT PERRY (1848–1933).
*Lady in an Evening Dress (Renée),* 1911.
Oil on canvas, 36 x 24 in. (91.4 x 61 cm).

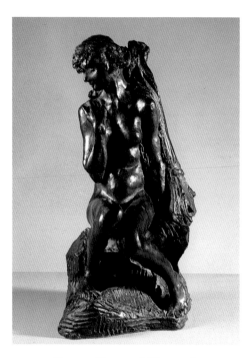

CAMILLE CLAUDEL (1864–1943).
*Young Girl with a Sheaf,* c. 1890.
Bronze, 14⅛ x 7 x 7½ in. (35.9 x 17.8 x 19.1 cm).

Margaret Lesley Bush-Brown (1857–1944).
*Woman Fishing in the Canal,* 1885.
Etching, 11⅞ x 7⅛ in. (30.2 x 18.1 cm).

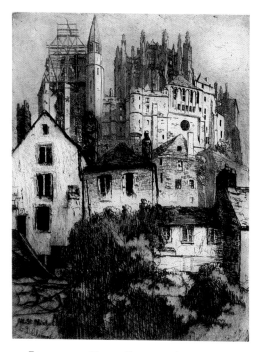

GABRIELLE DE VEAUX CLEMENTS (1858–1948).
*Church and Castle, Mont Saint Michel*, 1885.
Etching, 8½ x 6⅜ in. (21.6 x 16.2 cm).

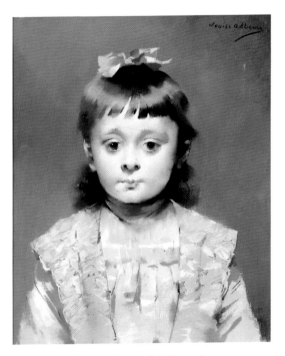

LOUISE ABBEMA (1858–1927).
*Portrait of a Young Girl with a Blue Ribbon*, n.d.
Pastel on canvas, 18 x 15 in. (45.7 x 38.1 cm).

LAURA MOTT (n.d.).
*Portrait of Mrs. Stuart,* 1896.
Pastel on paper, 29 x 26 in. (73.7 x 66 cm).

CLAUDE RAGUET HIRST (1855–1942).
*A Gentleman's Table*, n.d.
Oil on canvas, 18 x 32 in. (45.7 x 81.3 cm).

MINERVA CHAPMAN (1858–1947).
*Still Life: A Shelf in the Studio*, 1889.
Oil on canvas, 11 x 13⅝ in. (27.9 x 34.6 cm).

Elizabeth A. Armstrong Forbes (1859–1912).
*Will-o'-the-Wisp,* c. 1900. Oil on canvas, triptych,
27 x 44 in. (68.6 x 111.8 cm), overall.

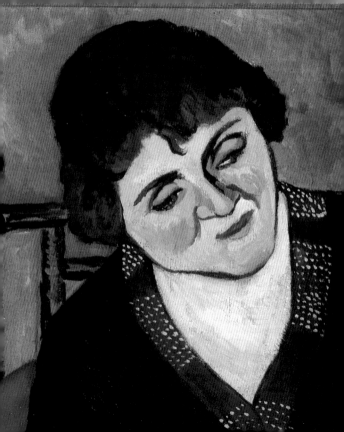

In the transition from the old guard to the avant-garde, women artists played active roles as they moved away from the limits of home and family. Suzanne Valadon lived a bohemian existence in Montmartre from the age of nine. Käthe Kollwitz was an active socialist, feminist, and pacifist who identified strongly with the plight of the working class. Sonia Delaunay sought to merge the fields of abstract painting, fashion, and design in her art.

Part of this change can be measured in the types of subjects that women now felt free to pursue—most notably, the nude. Valadon's painting of a pubescent young woman (page 146) and the portrait by Lotte Laserstein of a well-developed female athlete (page 180) are extremely different in spirit from the sensual nudes produced throughout history by male artists from Titian to Henri Matisse. Alice Neel's portrayal of a young man suffering from tuberculosis (page 183) presents a difficult, depressing subject, but it also confounds expectations that such a vulnerable nude would necessarily be female.

Other interesting issues come to light in artists' self-portraits. Alice Bailly, for example, dismissed traditional notions of beauty by depicting herself as a Cubist construction, complete with brushes and eyeglasses (page 148). Gabriele Münter showed only her back as she enjoyed her privacy in *Breakfast of the Birds* (page 158). Frida Kahlo candidly acknowledged her political alle-

giance to the Mexican Revolution and Marxism by wearing a Mexican peasant costume and holding a dedication to Leon Trotsky (page 184). Each of these works conveys the artist's self-possessed opinion of what a nude or a portrait should be. They are visions that point to a promising future as much as they acknowledge the legacy of the past.

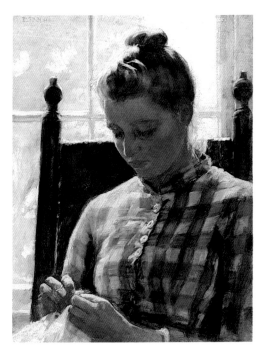

ELLEN DAY HALE (1855–1940).
*June,* c. 1905. Oil on canvas,
24 x 18⅛ in. (61 x 46 cm).

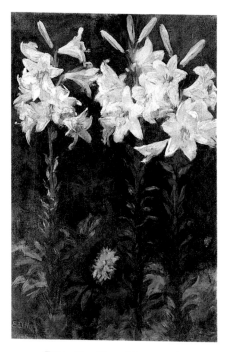

ELLEN DAY HALE (1855–1940).
*Lilies,* c. 1905.
Oil on canvas, 30 x 19⅛ in. (76.2 x 50.5 cm).

ELLEN DAY HALE (1855–1940).
*The Green Calash*, 1927.
Hand-colored etching, 11⅞ x 7 in. (30.2 x 17.8 cm).

LYDIA FIELD EMMET (1866–1952).
*Portrait of Thomas Ewing III,* c. 1932.
Oil on canvas, 44 x 32 in. (111.8 x 81.3 cm).

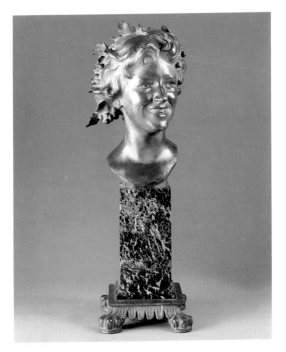

EVELYN BEATRICE LONGMAN (1874–1954).
*Peggy (Portrait of Margaret French),* 1912.
Bronze, 27½ x 12 x 10½ in. (69.9 x 30.5 x 26.7 cm).

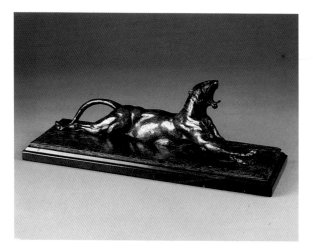

ANNA VAUGHN HYATT HUNTINGTON (1876–1973).
*Yawning Panther*, n.d.
Bronze, 5½ x 14¾ x 5¼ in. (14 x 37.5 x 13.3 cm).

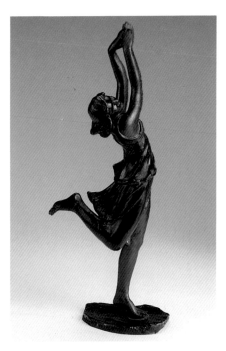

ABASTENIA SAINT EBERLE (1878–1942).
*Untitled,* n.d. Bronze, 17½ x 7 in. (44.5 x 17.8 cm).

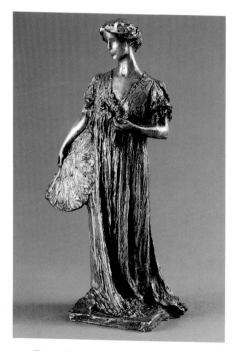

Bessie Potter Vonnoh (1872–1955).
*The Fan*, 1910. Silvered bronze,
11⅜ x 4¼ x 4 in. (28.9 x 10.8 x 10.2 cm).

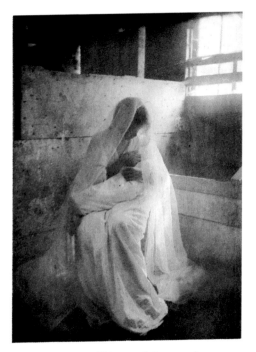

GERTRUDE KÄSEBIER (1852–1934).
*The Manger*, c. 1899.
Platinum print, 7⅛ x 5½ in. (18.1 x 14 cm).

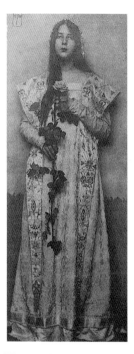

Eva Watson-Schütze (1867–1935).
*The Rose,* 1905.
Gum-bichromate print, 13⅜ x 5 in. (34 x 12.7 cm).

GERTRUDE KÄSEBIER (1852–1934).
*Eulabee Dix in Her Carnegie Hall Studio,* c. 1904.
Albumen print, 7½ x 9⅜ in. (19.1 x 23.8 cm).

EULABEE DIX (1878–1961).
*Ethel Barrymore*, c. 1905.
Watercolor on ivory, diameter: 2⅜ in. (6 cm).

EULABEE DIX (1878–1961).
*Boy with Red Hair*, c. 1913.
Watercolor on ivory, 2⅜ x 1⅞ in. (6 x 2.9 cm).

EULABEE DIX (1878–1961).
*Betty Sadler*, c. 1936.
Watercolor on ivory, 5⅜ x 4 in. (13.7 x 10.2 cm).

HARRIET WHITNEY FRISHMUTH (1880–1979).
*Playdays,* 1923. Bronze, height: 50⅛ in. (127.3 cm).

JESSIE MARION KING (1876–1949).
*Summer and Winter*, n.d.
Watercolor and ink on paper, 11½ x 9¼ in. (29.2 x 23.5 cm).

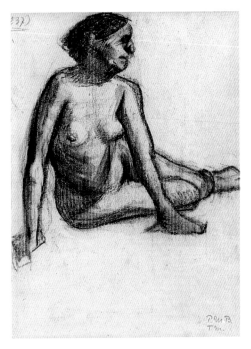

PAULA MODERSOHN-BECKER (1876–1907).
*Sitting Female Nude,* 1906.
Charcoal on paper, 11⅜ x 8⅜ in. (28.9 x 21.3 cm).

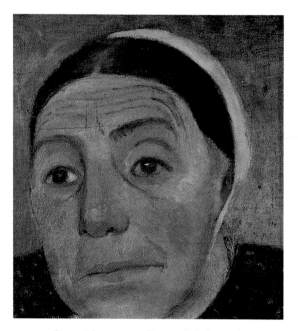

PAULA MODERSOHN-BECKER (1876–1907).
*Head of an Old Peasant Woman*, n.d.
Oil on panel, 9½ x 9 in. (24.1 x 22.9 cm).

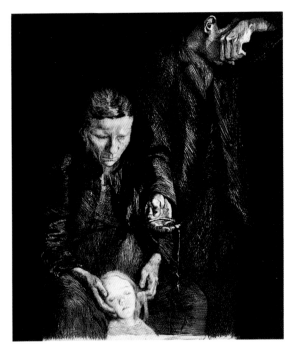

KÄTHE KOLLWITZ (1867–1945).
*The Downtrodden*, 1900.
Etching and aquatint, 12⅛ x 9¾ in. (30.8 x 24.8 cm).

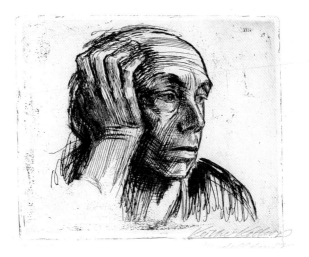

KÄTHE KOLLWITZ (1867–1945).
*Self-Portrait*, 1921.
Etching, 8½ x 10½ in. (21.6 x 26.7 cm).

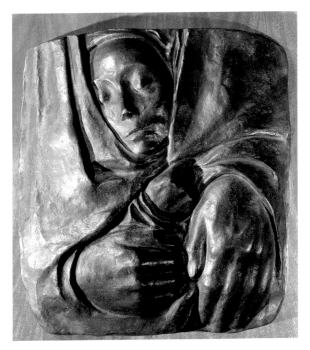

KÄTHE KOLLWITZ (1867–1945).
*Rest in His Hands*, c. 1936.
Bronze, 13½ x 12⅛ x 1¼ in. (34.3 x 30.8 x 3.2 cm).

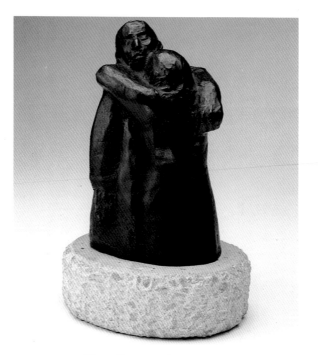

KÄTHE KOLLWITZ (1867–1945).
*The Farewell,* 1940. Bronze on composition base,
6¾ x 4 x 4½ in. (17.1 x 10.2 x 11.4 cm).

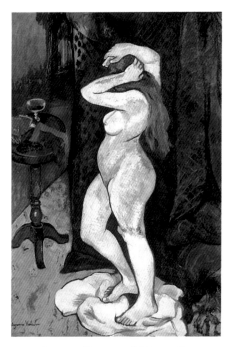

SUZANNE VALADON (1865–1938).
*Nude Doing Her Hair*, c. 1916.
Oil on canvasboard, 41¼ x 29⅝ in. (104.8 x 75.2 cm).

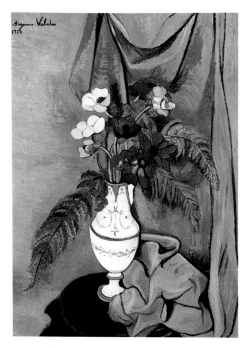

Suzanne Valadon (1865–1938).
*Bouquet of Flowers in an Empire Vase,* 1920.
Oil on canvas, 28¾ x 21½ in. (73 x 54.6 cm).

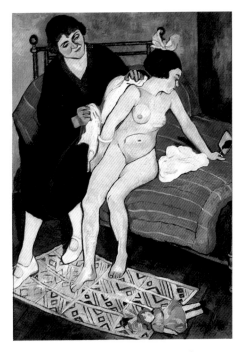

Suzanne Valadon (1865–1938).
*The Abandoned Doll,* 1921.
Oil on canvas, 51 x 32 in. (129.5 x 81.3 cm).

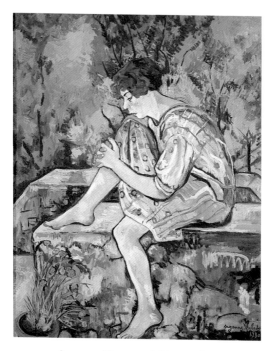

Suzanne Valadon (1865–1938).
*Girl on a Small Wall,* 1930.
Oil on canvas, 36¼ x 29 in. (92.1 x 73.7 cm).

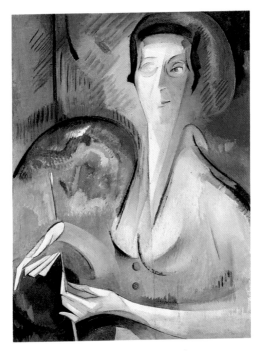

Alice Bailly (1872–1938).
*Self-Portrait*, 1917.
Oil on canvas, 32 x 23½ in. (81.3 x 59.7 cm).

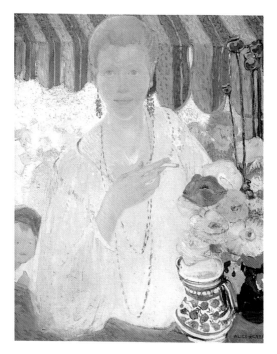

ALICE BEARD (n.d.).
*At the Flower Market,* c. 1921.
Oil on canvas, 27 x 21¾ in. (68.6 x 55.2 cm).

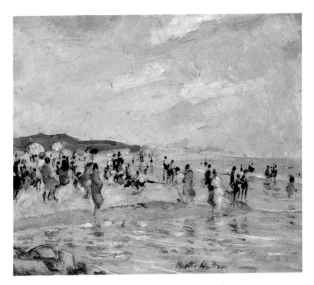

MARTHA WALTER (1875–1976).
*Bathing Hour,* c. 1915.
Oil on canvas, 10⅝ x 12¼ in. (26.7 x 31.1 cm).

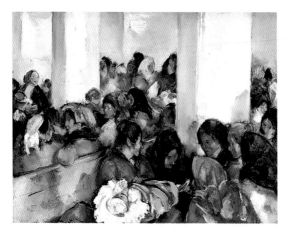

MARTHA WALTER (1875–1976).
*The Telegram, Detention Room, Ellis Island*, 1922.
Oil on panel, 14 x 18 in. (35.6 x 45.7 cm).

JANE PETERSON (1876–1965).
*Beach Scene*, n.d.
Oil on canvasboard, 12 x 15⅞ in. (30.5 x 40.3 cm).

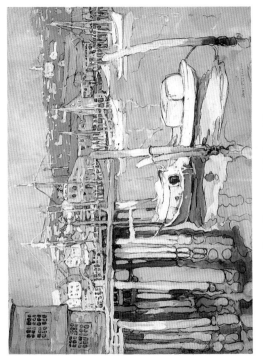

JANE PETERSON (1876–1965).
*Docks at Gloucester*, n.d.
Gouache and charcoal on paper, 18 x 24 in. (45.7 x 61 cm).

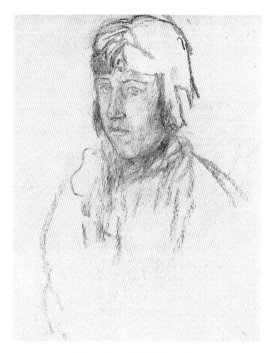

GWEN JOHN (1876–1939).
*Study of a Woman in Mulberry Dress,* n.d.
Charcoal on paper, 16⅞ x 8½ in. (42.9 x 21.6 cm).

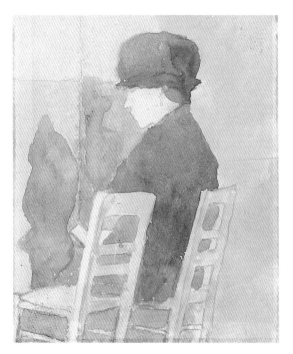

GWEN JOHN (1876–1939).
*Seated Woman*, c. 1924.
Gouache and pencil on paper, 8½ x 8 in. (21.6 x 20.3 cm).

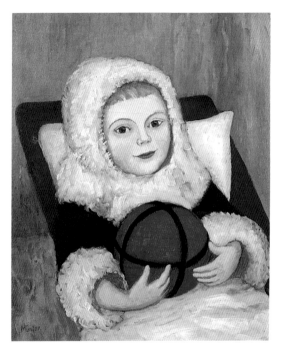

GABRIELE MÜNTER (1877–1962).
*Child with Ball,* c. 1916.
Oil on canvas, 20½ x 16⅞ in. (52 x 42.9 cm).

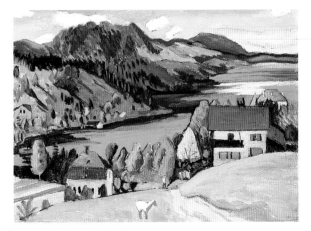

GABRIELE MÜNTER (1877–1962).
*Staffelsee in Autumn*, 1923.
Oil on board, 13¾ x 19¼ in. (34.9 x 48.9 cm).

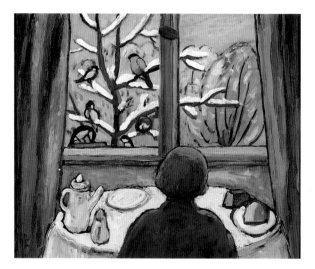

GABRIELE MÜNTER (1877–1962).
*Breakfast of the Birds,* 1934.
Oil on board, 18 x 21¾ in. (45.7 x 55.2 cm).

BEATRICE WHITNEY VAN NESS (1888–1981).
*Summer Sunlight*, c. 1936.
Oil on canvas, 39 x 49 in. (99.1 x 124.5 cm).

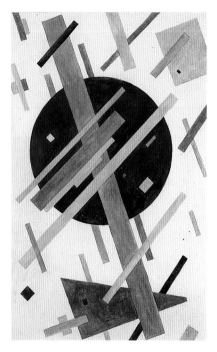

NINA KOGAN (1887–1942?).
*Composition*, c. 1921.
Watercolor on paper, 19⅞ x 13 in. (50.5 x 33 cm).

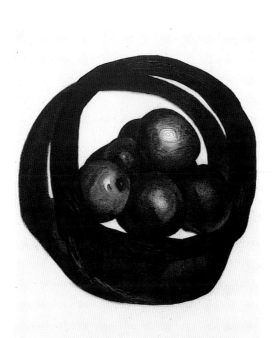

GEORGIA O'KEEFFE (1887–1986).
*Alligator Pears in a Basket,* 1923.
Charcoal on paper, 24⅞ x 18⅞ in. (63.2 x 47.9 cm).

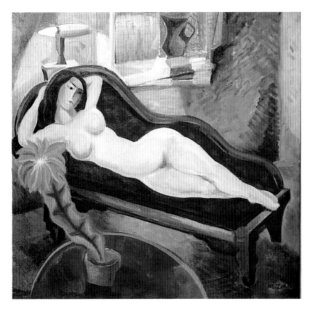

MARGUERITE THOMPSON ZORACH (1887–1968).
*Nude Reclining,* 1922.
Oil on canvas, 29⅛ x 30¼ in. (74 x 76.8 cm).

BERENICE ABBOTT (1898–1991).
*Djuna Barnes,* 1925.
Vintage silver print, 4 x 2½ in. (10.2 x 6.4 cm).

BERENICE ABBOTT (1898–1991).
*Edna Saint Vincent Millay,* c. 1927.
Vintage silver print, 11½ x 9¼ in. (29.2 x 23.5 cm).

BERENICE ABBOTT (1898–1991).
*Eva le Gallienne,* c. 1927.
Vintage silver print, 3½ x 4½ in. (8.9 x 11.4 cm).

BERENICE ABBOTT (1898–1991).
*Coco Chanel*, c. 1927.
Vintage silver print, 3 x 2¼ in. (7.6 x 5.7 cm).

BERENICE ABBOTT (1898–1991).
*Betty Parsons,* c. 1927.
Vintage silver print, 2 x 2¼ in. (5.1 x 5.7 cm).

EUDORA WELTY (born 1909).
*A Woman of the Thirties, Hinds County,* 1935 (printed 1980).
Gelatin silver print, 14 x 11⅛ in. (35.6 x 28.3 cm).

Louise Dahl-Wolfe (1895–1989).
*Ophelia, Nashville,* 1932.
Gelatin silver print, 12½ x 9⅝ in. (31.8 x 24.4 cm).

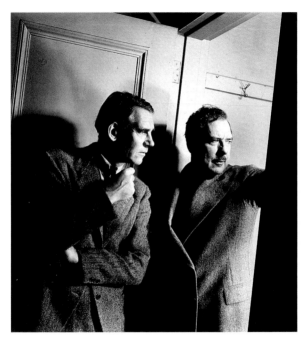

LOUISE DAHL-WOLFE (1895–1989).
*Maxwell Anderson with Walter Houston,* 1938.
Gelatin silver print, 12¼ x 9⅝ in. (31.1 x 24.4 cm).

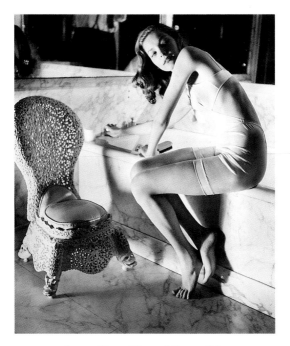

LOUISE DAHL-WOLFE (1895–1989).
*Lauren Bacall in Helena Rubinstein's Bathroom,* 1942.
Gelatin silver print, 11¼ x 9¾ in. (28.6 x 24.8 cm).

M. Marvin Breckinridge Patterson (born 1905).
*Woman Shelling Corn,* 1937.
Gelatin silver print, 13½ x 10½ in. (34.3 x 26.7 cm).

M. Marvin Breckinridge Patterson (born 1905).
*Mountain Family at Supper,* 1937.
Gelatin silver print, 13¼ x 10¼ in. (33.7 x 26 cm).

Imogen Cunningham (1883–1976).
*Portrait of Jesse Dorr Luca,* 1925.
Gelatin silver print, 7⅝ x 6½ in. (19.4 x 16.5 cm).

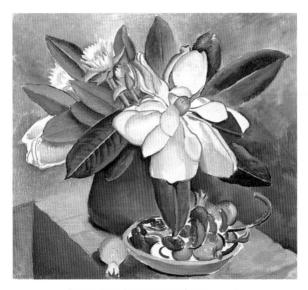

LAURA VAN PAPPLENDAM (1883–1974).
*Magnolia Blossom,* 1930.
Oil on canvas, 21 x 23 in. (53.3 x 58.4 cm).

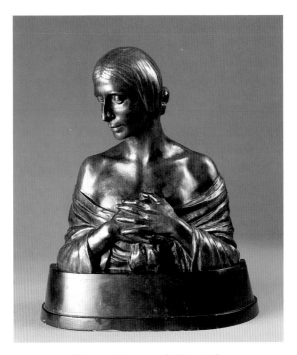

MALVINA HOFFMAN (1887–1966).
*Anna Pavlova,* 1926.
Bronze, 13 x 10½ x 6 in. (33 x 26.7 x 15.2 cm).

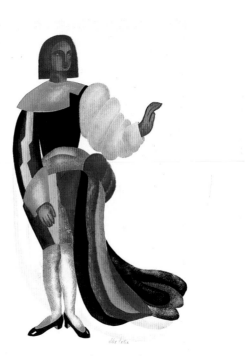

ALEXANDRA EXTER (1882–1949).
*Costume Design for "Les Equivoques d'Amour,"* c. 1933.
Gouache with pencil on paper, 22⅜ x 17⅛ in. (56.8 x 43.5 cm).

Minna Citron (1896–1991).
*Laning at Work*, 1933.
Etching and aquatint, 14 x 9¼ in. (35.6 x 23.5 cm).

WANDA GAG (1893–1946).
*First State,* 1933.
Lithograph, 19¾ x 22½ in. (50.2 x 57.2 cm).

LOTTE LASERSTEIN (1898–1990).
*Traute Washing,* c. 1930.
Oil on panel, 39¼ x 25⅝ in. (99.7 x 65.1 cm).

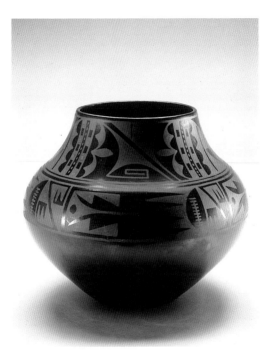

Maria Montoya Martinez (1881–1980).
*Jar, San Ildefonso Pueblo, New Mexico, c. 1939.*
Blackware, 11⅛ x 13 in. (28.3 x 33 cm).

GRACE ALBEE (1890–1985).
*Manhattan Backwash,* 1938. Wood engraving on
Japanese paper, 6⅝ x 8½ in. (16.5 x 21.6 cm).

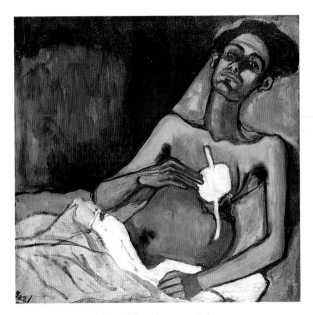

ALICE NEEL (1900–1988).
*T.B., Harlem,* 1940.
Oil on canvas, 30 x 30 in. (76.2 x 76.2 cm).

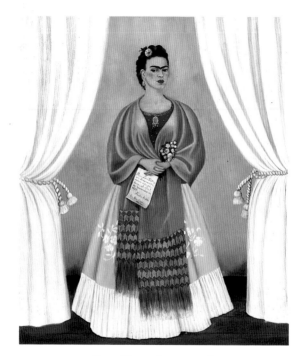

FRIDA KAHLO (1907–1954).
*Self-Portrait Dedicated to Leon Trotsky*, 1937.
Oil on Masonite, 30 x 24 in. (76.2 x 61 cm).

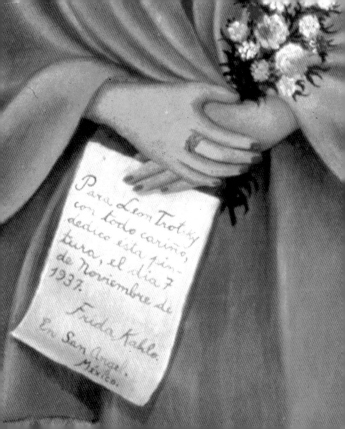

Sonia Delaunay (1885–1979).
*Study for Portugal*, c. 1937.
Gouache on paper, 14¼ x 37 in. (36.2 x 94 cm).

SONIA DELAUNAY (1885–1979).
*Untitled,* n.d.
Lithograph (12/125), 29⅛ x 25¼ in. (74 x 64.1 cm).

Sᴏᴘʜɪᴇ Tᴀᴇᴜʙᴇʀ-Aʀᴘ (1889–1943).
*Composition of Circles and Semicircles,* 1935.
Gouache on paper, 10 x 13½ in. (25.4 x 34.3 cm).

189

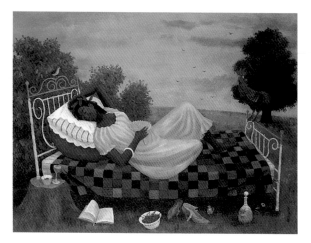

DORIS LEE (1905–1983).
*Cherries in the Sun (Siesta)*, c. 1941.
Oil on canvas, 27 x 36 in. (68.6 x 91.4 cm).

# THE POSTWAR ERA

This is so good, you would not know it was
painted by a woman.

*Hans Hofmann about his student*
*Lee Krasner, c. 1937*

In the years just after World War II, American artists
practicing a new style known as Abstract Expressionism
emerged as leaders in the art world. Coincident with the
wider recognition of the United States as a world power,
Western Europeans for the first time began to look to
New York for artistic direction. Abstract Expressionism,
as the name suggests, combined two important strains of
modern art: abstraction, which emphasized a nonrepre-
sentational approach to form and color, and expression-
ism, which sought emotional responses from both artist
and viewer.

At its inception and for twenty years to come, all the
artists trumpeted as the masters of Abstract Expression-
ism were men—Willem de Kooning, Jackson Pollock,
Mark Rothko, David Smith—in spite of the fact that
many important practitioners of the style, especially dur-
ing the 1950s, were women. Indeed, most of the women
Abstract Expressionists had to fight for recognition of

their art throughout their careers. This was especially true for the most prominent among them—Lee Krasner, Elaine de Kooning, and Dorothy Dehner—whose art was treated as less serious than that by their more celebrated spouses: Pollock, de Kooning, and Smith. The assumption that one would not be taken seriously as a woman was so pervasive that even an accomplished painter like Grace Hartigan chose to be known as "George" in the early days of her career. Widespread appreciation of these artists' achievements generally did come, although much later in life than for their male counterparts.

Like Grace Hartigan, such younger artists as Helen Frankenthaler and Joan Mitchell gravitated to the downtown New York art world of the 1950s and began their careers as Abstract Expressionists. Frankenthaler, in particular, is well known for developing a new technique of soaking diluted paint directly into unprimed canvas. She used this innovative stain technique to create color-filled canvases, like *Spiritualist* (page 246), that seem to float on air. Her work in this vein formed a bridge between Abstract Expressionist painting of the 1950s and color-field painting of the 1960s.

Many of the Abstract Expressionist and color-field paintings in this section call to mind landscapes: Krasner's use of earthy colors in *The Springs* (page 219); Har-

tigan's use of a marked horizon line in *December Second* (page 225); and Alma Thomas's colorful brushstrokes in *Iris, Tulips, Jonquils, and Crocuses* (page 240), which suggest a hanging bower. In their dialogue with nature, these artists continued the American landscape tradition, reinterpreting it in terms of mid-twentieth-century abstraction.

LOUISE DAHL-WOLFE (1895–1989).
*Millicent Rogers,* 1946.
Gelatin silver print, 11½ x 9⅜ in. (29.2 x 23.8 cm).

LOUISE DAHL-WOLFE (1895–1989).
*Mary Jane Russell in Dior Dress,* 1950.
Gelatin silver print, 10½ x 8⅞ in. (26.7 x 22.5 cm).

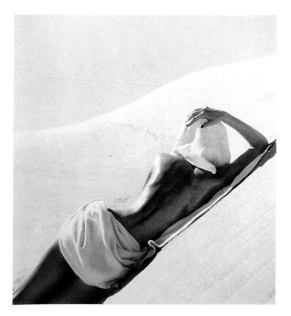

LOUISE DAHL-WOLFE (1895–1989).
*California Desert,* 1948.
Gelatin silver print, 10 x 9⅜ in. (25.4 x 23.8 cm).

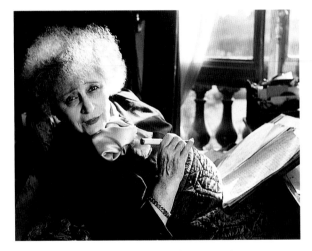

LOUISE DAHL-WOLFE (1895–1989).
*Colette,* 1951.
Gelatin silver print, 10⅞ x 13⅛ in. (27.6 x 33.3 cm).

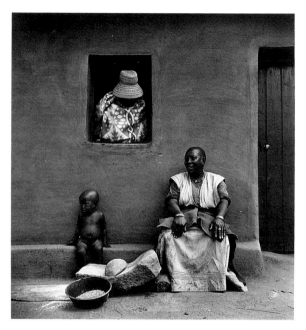

CONSTANCE STUART LARRABEE (born 1914).
*Basuto Family, Lesotho, South Africa,* 1947.
Gelatin silver print, 12½ x 11⅞ in. (31.8 x 30.2 cm).

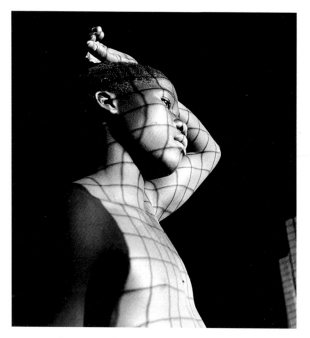

Constance Stuart Larrabee (born 1914).
*Witwatersrand Goldminer Watching Sunday Mine Dance, Johannesburg, South Africa,* 1946. Gelatin silver print, 11⅞ x 11¾ in. (30.2 x 30 cm).

Lola Alvarez Bravo (born 1907).
*From Generation to Generation*, c. 1950.
Gelatin silver print, 9 x 6⅛ in. (22.9 x 15.6 cm).

MARIE LAURENCIN (1885–1956).
*Portrait of a Girl in a Hat,* c. 1950.
Oil on canvasboard, 15 x 11¾ in. (38.1 x 29.8 cm).

KAY SAGE (1898–1965).
*Tomorrow, for Example,* 1951.
Oil on canvas, 20 x 17 in. (50.8 x 43.2 cm).

LEONOR FINI (born 1908).
*Untitled,* n.d. Lithograph with pastel (107/186),
17¾ x 12 in. (45.1 x 30.5 cm).

LOUISE BOURGEOIS (born 1911).
*Untitled,* 1949.
Ink on paper, 9⅞ x 15⅝ in. (25.1 x 39.7 cm).

DOROTHY DEHNER (1901–1994).
*Untitled*, 1951.
Ink and watercolor on paper, 20½ x 15¾ in. (52.1 x 40 cm).

DOROTHY DEHNER (1901–1994).
*Looking North F,* 1964.
Bronze, 18 x 64½ x 3 in. (45.7 x 163.8 x 7.6 cm).

DOROTHY DEHNER (1901–1994).
*Black and Brown,* 1970.
Lithograph, 22¼ x 30 in. (56.5 x 76.2 cm).

209

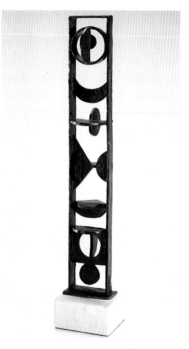

DOROTHY DEHNER (1901–1994).
*Ladder II,* 1976.
Bronze, 23 x 3½ x 1½ in. (58.4 x 8.9 x 3.8 cm).

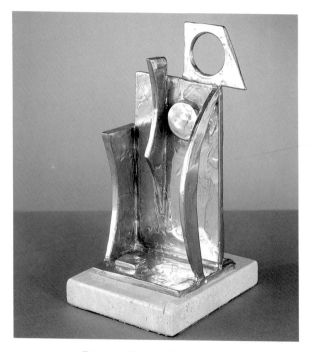

Dorothy Dehner (1901–1994).
*Sanctuary,* 1984.
Bronze, height: 7⅝ in. (19.4 cm).

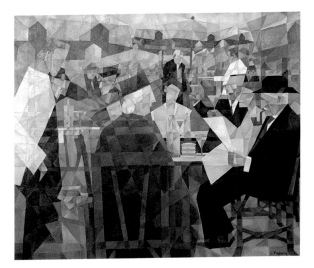

CELINE M. TABARY (n.d.).
*Café Terrace, Paris*, 1950.
Oil on canvas, 31½ x 39 in. (80 x 99.1 cm).

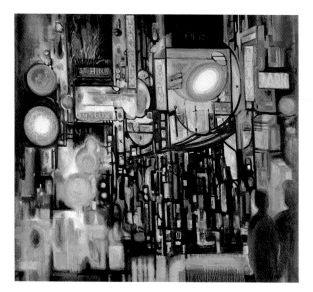

GEORGIA MILLS JESSUP (born 1926).
*Rainy Night Downtown,* 1967.
Oil on canvas, 44 x 48 in. (111.8 x 121.9 cm).

NATALYA SERGEEVNA GONCHAROVA (1881–1962).
*Cosmic Universe,* c. 1957.
Watercolor on paper, 12⅞ x 9¼ in. (32.7 x 23.5 cm).

HANNAH HÖCH (1889–1978).
*In Front of a Red Sunset,* n.d.
Oil on canvas, 31½ x 29¾ in. (80 x 75.6 cm).

Charmion Von Wiegand (1900–1983).
*Advancing Magic Squares,* c. 1958.
Oil on canvas, 12⅛ x 22½ in. (30.8 x 57.2 cm).

CHARMION VON WIEGAND (1900–1983).
*Untitled (Cat in Window)*, n.d.
Oil on canvas, 20¼ x 24 in. (51.4 x 61 cm).

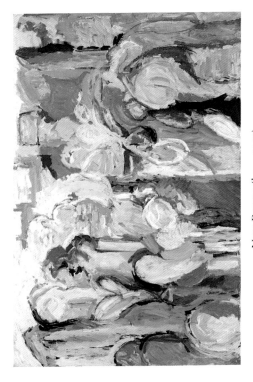

NELL BLAINE (born 1922).
*Troubadours,* 1954–55.
Oil on canvas, 40 x 60 in. (101.6 x 152.4 cm).

Lee Krasner (1908–1984).
*The Springs*, 1964.
Oil on canvas, 43 x 66 in. (109.2 x 167.6 cm).

Maria Elena Vieira da Silva (1908–1992).
*The Town*, 1955.
Oil on canvas, 39½ x 31¾ in. (100.3 x 80.6 cm).

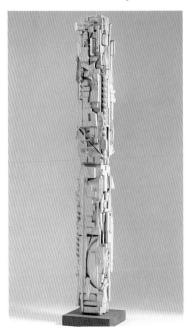

LOUISE NEVELSON (1900–1988).
*White Column,* from the two-part sculpture
*Dawn's Wedding Feast,* 1959.
Painted wood, height: 108 in. (274 cm).

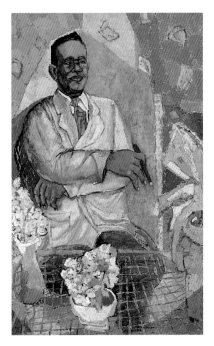

IDA KOHLMEYER (born 1912).
*Chauffeur,* 1956.
Oil on Masonite, 38 x 23¾ in. (96.5 x 60.3 cm).

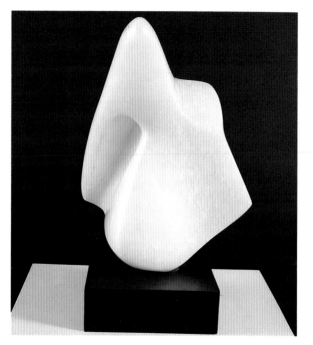

MARINA NUÑEZ DEL PRADO (born 1912).
*Mother and Child,* 1967.
White onyx, 16¾ x 13¼ x 10 in. (42.5 x 33.7 x 25.4 cm).

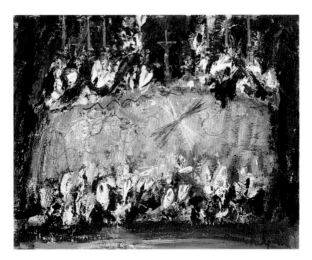

ANNE REDPATH (1895–1965).
*Altar in Venice*, c. 1962.
Oil on paper, 23½ x 29⅝ in. (59.7 x 75.2 cm).

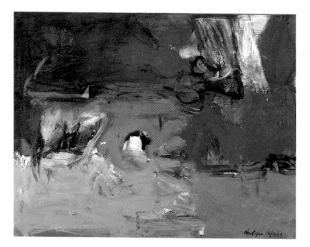

GRACE HARTIGAN (born 1922).
*December Second,* 1959.
Oil on canvas, 48 x 72 in. (121.9 x 182.9 cm).

Ruth Gikow (1915–1982).
*Prayer for the Dead,* panel from *The Burial* triptych, 1964.
Oil on canvas, 60 x 60 in. (152.4 x 152.4 cm).

ISABEL BISHOP (1902–1988).
*Men and Girls Walking,* 1969.
Aquatint, 8⅜ x 11½ in. (21.3 x 29.2 cm).

AGNES MARTIN (born 1912).
*The Wall #2*, 1962. Oil on canvas mounted on board
with nails, 10 x 10 in. (25.4 x 25.4 cm).

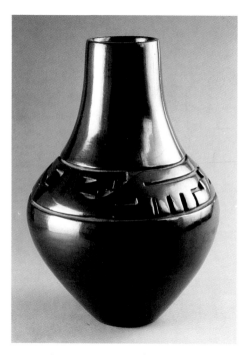

MARGARET TAFOYA (born 1904).
*Jar, Santa Clara Pueblo, New Mexico,* c. 1965.
Blackware, 17 x 13 in. (43.2 x 33 cm).

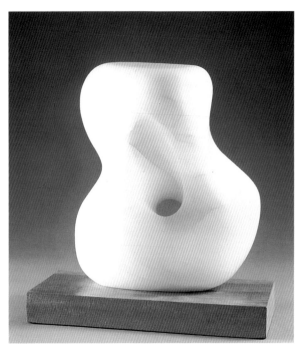

BARBARA HEPWORTH (1904–1975).
*Merryn,* 1962.
Alabaster, 13 x 11½ x 8¼ in. (33 x 29.2 x 21 cm).

JUDITH GODWIN (born 1930).
*Epic,* 1959. Acrylic on canvas, diptych,
50 x 82 in. (127 x 208.3 cm), each.

ALICE BABER (1928–1982).
*Burning Boundary,* 1963.
Oil on canvas, 24 x 19½ in. (61 x 49.5 cm).

ALICE BABER (1928–1982).
*For a Book of Kings,* 1974.
Oil on canvas, 77 x 58 in. (195.6 x 147.3 cm).

VIRGINIA BERRESFORD (born 1902).
*Fair Weather,* 1965.
Oil on canvas, 23½ x 29¼ in. (59.7 x 74.3 cm).

Virginia Berresford (born 1902).
*Abandoned Cottage,* 1968.
Oil on canvas, 24 x 30 in. (61 x 76.2 cm).

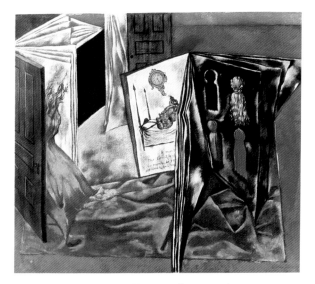

DOROTHEA TANNING (born 1910).
*To Max Ernst*, c. 1970.
Aquatint, 15¼ x 17¼ in. (38.7 x 43.8 cm).

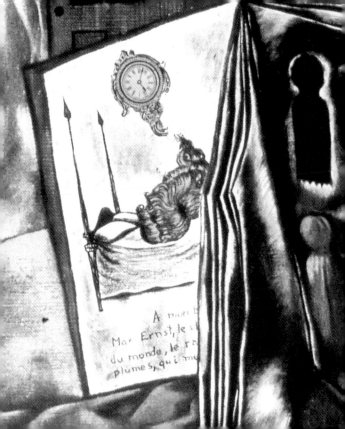

ANNI ALBERS (1899–1993).
*Untitled,* 1969.
Serigraph, 24 x 22½ in. (61 x 57.2 cm).

ANNI ALBERS (1899–1993).
*Dr. VII,* 1973.
Ink and pencil on paper, 18¼ x 12⅝ in. (46.4 x 32 cm).

ALMA THOMAS (1891–1978).
*Iris, Tulips, Jonquils, and Crocuses*, 1969.
Acrylic on canvas, 60 x 50 in. (152.4 x 127 cm).

ALMA THOMAS (1891–1978).
*Orion*, 1973.
Oil on canvas, 64 x 53¾ in. (162.6 x 136.5 cm).

BRIDGET RILEY (born 1931).
*Cerise, Olive, Turquoise Disks,* 1970.
Gouache and pencil on paper, 26¾ x 26⅝ in. (67.9 x 67.6 cm).

BRIDGET RILEY (born 1931).
*Red, Turquoise, Grey, and Black Bands,* 1971.
Gouache on paper, 27½ x 27½ in. (69.9 x 69.9 cm).

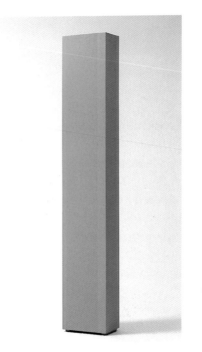

ANNE TRUITT (born 1921).
*Summer Dryad,* 1971.
Acrylic on wood, 76 x 13 x 8 in. (193 x 33 x 20.3 cm).

HELEN FRANKENTHALER (born 1928).
*Untitled*, 1969.
Acrylic on canvas, 15⅜ x 16 in. (39.1 x 40.6 cm).

HELEN FRANKENTHALER (born 1928).
*Spiritualist,* 1973.
Acrylic on canvas, 72 x 60 in. (182.9 x 152.4 cm).

HELEN FRANKENTHALER (born 1928).
*Ponti*, 1973.
Aquatint with drypoint, 19½ x 27⅝ in. (49.5 x 70.2 cm).

# THE 1970S TO THE 1990S

Abuse of power comes as no surprise. . . .
Analyze history. . . . Question authority. . . .
Raise boys and girls the same way.

*Jenny Holzer*, Truisms, *1983–87*

The 1970s and 1980s were a time of reassessment and realignment in the United States and in the world at large. New ways of seeing became part of this tide of change. Not only did artists involve themselves in political and social causes, they also sought to transform the world of art. Weary of the dominance of modernist theory, artists in all media jettisoned theories of pure form and color in favor of more inclusive ideas, experimental media, and new definitions of the power relationships within the arts.

"Pluralism" was the buzzword used most often in art criticism of the 1970s to describe this shift toward greater diversity, as Minimalism and Conceptualism yielded to process art and earthworks, video and performance, New Image and pattern painting, photography and installation art. This period is now often described as the beginning of "postmodernism," in which modern notions of what art can be about, who makes it, and why were all thrown open to question.

Women were prominent among the groups calling for redefinition and enfranchisement in the art world. They protested against the exclusionist policies of the Museum of Modern Art, the Metropolitan Museum of Art, and the Whitney Museum of American Art (1970); created the feminist Womanhouse in Los Angeles (1972); held the First National Conference of Women in the Arts in Washington, D.C. (1972); and introduced revisionist exhibitions such as *Women Artists: 1550–1950* (1976), a monumental historical overview that helped establish women's contributions to the history of art.

Concurrent with the founding of women's studies departments and the new feminist and postmodern revisions of art history, women became advocates for greater access for women to exhibition space in alternative spaces, galleries, and museums. Through an extended network of new exhibition venues, artists such as Alice Aycock, Dara Birnbaum, Nancy Graves, Eva Hesse, Shigeko Kubota, Ana Mendieta, Elizabeth Murray, Faith Ringgold, Susan Rothenberg, and Miriam Schapiro first presented their work. Their art was reviewed in the art press and purchased by museums and collectors. This acceptance set the stage for our future. Although women—especially women of color—still are underrepresented and undercompensated in the system, it is important to point out that women's first real inroads

into the mainstream of culture have been made during the past quarter-century.

The National Museum of Women in the Arts' collection exemplifies a number of the trends that constitute postmodern pluralism. Works by the Minimalist artist Dorothea Rockburne (pages 260 and 261) coexist with the process art of Eva Hesse (pages 252 and 253) and "femmage" prints by Miriam Schapiro (pages 272–75). Breaking down the distinctions between abstraction and representation is an important principle behind the paintings of Elaine de Kooning (pages 264 and 265) and Alice Aycock's designs for her sculpture (page 269). Reinterpretations of representational art abound as well, in Audrey Flack's Photo-Realism (pages 278–79), in the psychosexual drawings of Dottie Attie (pages 270 and 271), and in Jaune Quick-to-See Smith's mixed-media collage paintings (page 304).

No longer the miraculous exception, women artists today are extending the boundaries of art to encompass new visions. We no longer need to ask ourselves "Why Have There Been No Great Women Artists?" as Linda Nochlin did in her groundbreaking 1971 article. Instead, the question for the next millennium becomes, "When will women reach full artistic and social equality?" We are relying upon the women artists of today and their growing public to help ensure that women achieve that equality.

EVA HESSE (1936–1970).
*Accession,* 1967. Gouache and pencil on paper,
15⅜ x 11⅛ in. (39.1 x 28.3 cm).

Eva Hesse (1936–1970).
*Study for Sculpture,* 1967. Sculpmetal, cord, acrylic medium, glue, and varnish on Masonite,
10 x 10 x 1 in. (25.4 x 25.4 x 2.54 cm).

CLEMENTINE HUNTER (1887–1988).
*Call to Church and Flowers,* 1970.
Oil on canvas, 36 x 48 in. (91.4 x 121.9 cm).

GERTRUDE MORGAN (1900–1980).
*Sister Gertrude Morgan,* n.d. Gouache, pencil, and ink
on paper, 8¼ x 10½ in. (21 x 26.7 cm).

NANCY GROSSMAN (born 1940).
*Spring Diary*, 1973.
Collage on paper, 28⅞ x 39¾ in. (73.3 x 101 cm).

KIKI KOGELNIK (born 1935).
*Superwoman*, 1973.
Oil and acrylic on canvas, 90 x 60 in. (228.6 x 152.4 cm).

LEONORA CARRINGTON (born 1917).
*The Magic Witch,* 1975.
Gouache on vellum, 47¾ x 32⅜ in. (121.3 x 82.2 cm).

Leonora Carrington (born 1917).
*Crookhey Hall*, 1986.
Lithograph, 17⅛ x 30 in. (43.5 x 76.2 cm).

Dorothea Rockburne (born 1934).
*Copal #7,* 1976. Kraft paper with varnish and pencil,
29⅛ x 39⅛ in. (74 x 99.4 cm).

DOROTHEA ROCKBURNE (born 1934).
*Sheba,* 1980. Gesso, oil, Conté crayon, and glue on linen,
74 x 59½ in. (188 x 151 cm).

MARY GRIGORIADIS (born 1942).
*Persian Steep,* 1977.
Oil on canvas, 66 x 66 in. (167.6 x 167.6 cm).

BETTY PARSONS (1900–1982).
*Winged Frog,* 1978. Mixed-media wood construction,
27 x 20 in. (68.6 x 50.8 cm).

263

ELAINE DE KOONING (1920–1989).
*Bacchus #3,* 1978.
Acrylic and charcoal on canvas, 78 x 50 in. (198.1 x 127 cm).

ELAINE DE KOONING (1920–1989).
*Jardin de Luxembourg VII,* 1977.
Lithograph, 30 x 22 in. (76.2 x 55.9 cm).

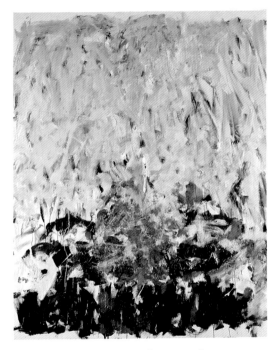

JOAN MITCHELL (1926–1992).
*Sale Neige,* 1980.
Oil on canvas, 86¼ x 70⅞ in. (219.1 x 180 cm).

Mirella Bentivoglio (born 1922).
*To Malherbe*, 1975.
Pink marble, 5⅜ x 7⅛ x 2¼ in. (13.7 x 18.1 x 5.7 cm).

HARMONY HAMMOND (born 1934).
*Adelphi,* 1979. Cloth, foam and latex rubber, Rhoplex, and wood, 30½ x 68½ x 13 in. (77.5 x 174 x 33 cm).

ALICE AYCOCK (born 1946).
*The Great God Pan*, 1980.
Graphite on nylon, 42½ x 52½ in. (108 x 133.4 cm).

DOTTIE ATTIE (born 1938).
*An Adventure at Sea,* 1977. Colored pencil on paper,
thirty-three drawings, 5¼ x 5¼ in. (13.3 x 13.3 cm), each.

While traveling abroad, Pierre discovered a peculiar device in an old shop specializing in antique curiosities

For some time it lay in his portmanteau, wrapped and forgotten

MIRIAM SCHAPIRO (born 1923).
*Mechano/Flower Fan*, 1979. Acrylic and fabric collage on paper,
30 x 34 in. (76.2 x 86.4 cm).

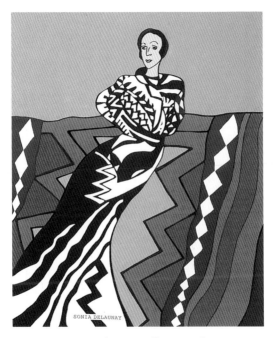

SONIA DELAUNAY

MIRIAM SCHAPIRO (born 1923).
*Delaunay*, from the folio *Delaunay, Goncharova, Popova and Me*
(edition 27), 1992. Screenprint on custom-made paper,
28 x 22 in. (71.1 x 55.9 cm).

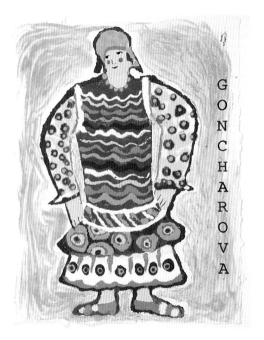

GONCHAROVA

MIRIAM SCHAPIRO (born 1923).
*Goncharova,* from the folio *Delaunay, Goncharova, Popova and Me*
(edition 27), 1992. Black-and-white color-based screen paint-
ing on custom-made paper, 28 x 22 in. (71.1 x 55.9 cm).

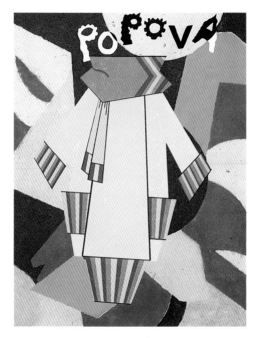

Miriam Schapiro (born 1923).
*Popova*, from the folio *Delaunay, Goncharova, Popova and Me*
(edition 27), 1992. Black-and-white color-based screen paint-
ing on custom-made paper, 28 x 22 in. (71.1 x 55.9 cm).

KAREN T. BORCHERS (born 1957).
*Growing Up, Coming Out*, 1991.
Gelatin silver print, 10⅞ x 14 in. (27.7 x 35.6 cm).

JOYCE TENNESON (born 1945).
*Kathy,* 1985.
Silver-bromide print, 22⅞ x 14⅞ in. (58.1 x 37.8 cm).

She has Stars in the Sunrise
lightening on a sunny day
Riding on the ocean!

She is lifting so many far above us now
Over our politics of love
Over the limits of consciousness___

AUDREY FLACK (born 1931).
*Hannah: Who She Is,* 1982.
Acrylic and oil on canvas, 84 x 60¼ in. (213.4 x 153 cm).

AUDREY FLACK (born 1931).
*Rolls Royce Lady,* 1983.
Cibachrome print, 18⅞ x 22½ in. (47.9 x 57.2 cm).

AUDREY FLACK (born 1931).
*Untitled,* from *Audrey Flack Sketchbook, 1985–1989,*
NMWA Library Fellows' edition 1/20, 1992.
Red pencil on paper, 5¾ x 4 in. (14.6 x 10.2 cm).

Priscilla Roberts (born 1916).
*Marengo,* 1986.
Oil on Masonite, 23½ x 19½ in. (59.7 x 49.5 cm).

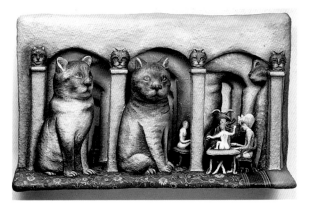

JOAN DANZINGER (born 1934).
*Ozymandias,* 1982.
Mixed media, 31 x 50 x 12¾ in. (78.7 x 127 x 32.4 cm).

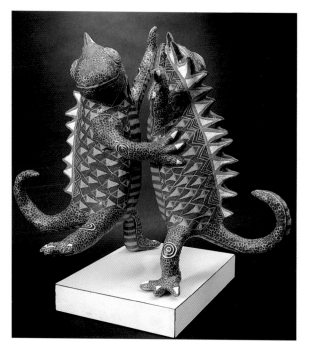

Ann Hanson (born 1959).
*Dancing Lizard Couple*, 1985.
Celluclay, 16½ x 20½ in. (41.9 x 52.1 cm).

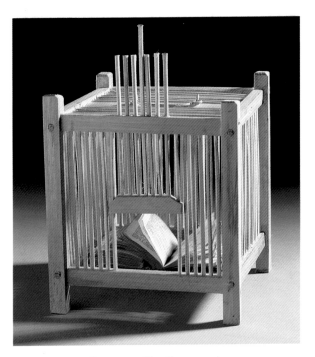

ELISABETTA GUT (born 1934).
*Book in a Cage,* 1981. Wood, wire, and French-Italian
dictionary, 4¾ x 4½ x 5¼ in. (12.1 x 11.4 x 13.3 cm).

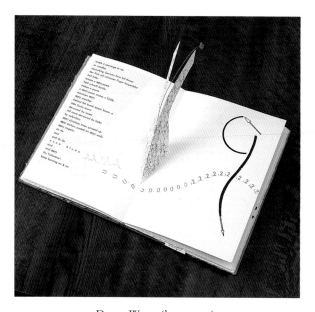

DEBRA WEIER (born 1954).
*A Merz Sonata,* 1985. Etchings, rubber stamp, collage, and
handmade paper, with poems by Jerome Rothenberg,
11½ x 8¼ in. (29.2 x 21 cm).

IDA KOHLMEYER (born 1912).
*Symbols,* 1981. Oil, graphite, and pastel on canvas,
69½ x 69 in. (176.5 x 175.3 cm).

IDA KOHLMEYER (born 1912).
*Quartered*, 1981.
Serigraph, 35 x 38⅛ in. (88.9 x 96.8 cm).

Yuriko Yamaguchi (born 1948).
*Shoot,* 1982.
Watercolor on handmade paper, 9 x 12 in. (22.9 x 30.5 cm).

BEVERLY PEPPER (born 1924).
*Benet,* 1983–84.
Steel with wood, 47 x 4¾ x 4¾ in. (119.4 x 12.1 x 12.1 cm).

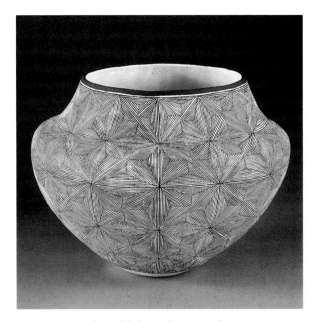

LUCY M. LEWIS (1902–1992).
*Jar, Acoma Pueblo, New Mexico*, 1983.
Earthenware, 9½ x 12 in. (24.1 x 30.5 cm).

MARCIA GYGLI KING (born 1931).
*Storm Series II*, 1984. Acrylic, pastel, and modeling paste on paper, 51⅞ x 74¼ in. (131.8 x 188.6 cm).

LEE WEISS (born 1928).
*Bright Moonlight*, 1985.
Watercolor on paper, 32¼ x 45¼ in. (81.9 x 114.9 cm).

Soo Ja Kim (born c. 1960).
*The Earth,* 1984. Acrylic, fiber, ink, and cotton thread,
48 x 78 in. (121.9 x 198.1 cm).

ZIVA KRONZON (n.d.).
*Empty Pods,* 1986. Cast paper, pigments,
25 x 25 x 11 in. (63.5 x 63.5 x 27.9 cm).

ELENA BONAFONTE VIDOTTO (born 1934).
*Eggs,* 1977.
Oil on panel, 10 x 12 in. (25.4 x 30.5 cm).

Beverly Hallam (born 1923).
*Paperweight,* 1987.
Acrylic on canvas, 71¾ x 48¼ in. (182.2 x 122.6 cm).

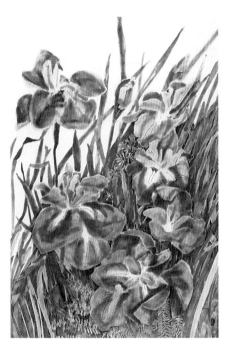

Patricia Tobacco Forrester (born 1940).
*December Irises,* n.d.
Color etching (8/50), 26⅞ x 18⅞ in. (68.3 x 47.9 cm).

ANNE SHREVE (born 1926).
*Blue Still Life,* 1989.
Oil on canvas, 35½ x 39½ in. (90.2 x 100.3 cm).

Lake spirit    A P II/X    D. DeArmond-imp © 1988

DALE DE ARMOND (born 1914).
*Lake Spirit,* 1988.
Wood engraving, 6 x 5 in. (15.2 x 12.7 cm).

Raven made women          A.P.          Dale DeArmond - wanf ©90

DALE DE ARMOND (born 1914).
*Raven Made Women*, 1990.
Wood engraving, 6 x 5 in. (15.2 x 12.7 cm).

PAMELA ROBERSON (born 1947).
*Nevada,* 1981.
Cibachrome print, 16⅝ x 23¾ in. (42.2 x 60.3 cm).

Connie Imboden (born 1953).
*Untitled,* 1992.
Gelatin silver print, 10¾ x 17 in. (27.3 x 43.2 cm).

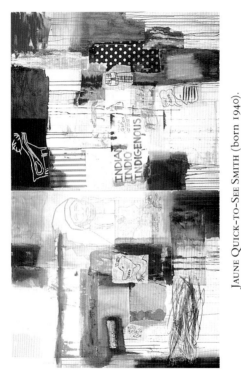

JAUNE QUICK-TO-SEE SMITH (born 1940).
*Indian, Indio, Indigenous,* 1992.
Oil, collage, and mixed media on canvas, 60 x 100 in. (152.4 x 254 cm).

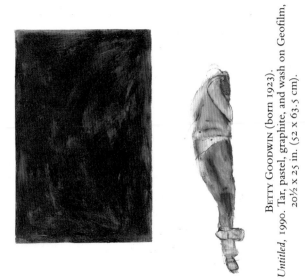

BETTY GOODWIN (born 1923).
*Untitled*, 1990. Tar, pastel, graphite, and wash on Geofilm,
20½ x 25 in. (52 x 63.5 cm).

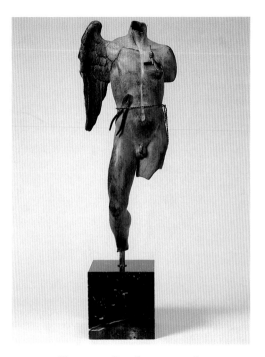

YOUNG-JA CHO (born c. 1955).
*Untitled,* n.d.
Bronze, 35¼ x 14¾ x 12½ in. (89.5 x 37.5 x 31.8 cm).

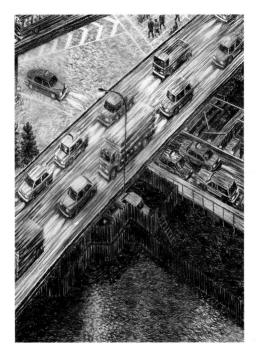

Yvonne Jacquette (born 1934).
*Elevated Traffic over Moat and Bridge*, 1986.
Charcoal on vellum, 60½ x 45¾ in. (153.7 x 116.2 cm).

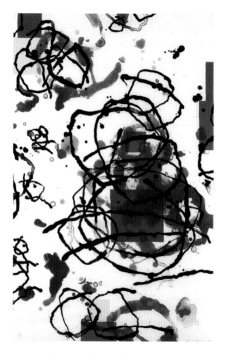

LOUISA CHASE (born 1951).
*Untitled,* 1988.
Lithograph on Sekishu paper, 39 x 24½ in. (99 x 62.2 cm).

Frida Baranek (born 1961).
*Untitled*, 1991.
Iron, 43 x 39 x 75 in. (109.2 x 99.1 x 190.5 cm).

SUE COE (born 1952).
*Thank You America (Anita Hill),* 1991.
Lithograph (9/30), 46 x 32 in. (116.8 x 81.3 cm).

# INDEX OF CREDITS

*All works from the collection of The National Museum of Women in the Arts reproduced in this volume were the generous gift of Wallace and Wilhelmina Holladay, unless otherwise indicated below.*

*Names are alphabetized according to the donors' last name; numerals refer to page numbers.*

Gift of P. Frederick Albee, 182

Gift of Dorothy C. Allen, 178

Gift of the artist [Alvarez Bravo], 202

Gift of an anonymous donor, 204, 221

Gift of an anonymous donor in honor of the artist [Berresford], 234, 235

Purchased with funds donated anonymously, 278

Gift of the artist [Armond], 300, 301

Gift of the estate of Alice Baber, 233

Gift of Mrs. Philip Dix Becker and family, 133

Gift of the artist [Bentivoglio], 267

Gift of the Board of Directors, 180

Gift of Diana T. Brown, 70

Gift of Business Committee for the Arts, Inc., 308

Gift of Mr. and Mrs. Kenneth S. Carpenter, 245

Gift of the artist [Carrington], 259

Gift of The Honorable Joseph P. Carroll and Mrs. Carroll, 257, 281

Gift of Mrs. W. E. Chilton III, 128

Gift of Mr. and Mrs. Kenneth G. Clare, 223

Gift of Savanna M. Clark, 213

Gift of Arthur Cohen, 218

Gift of Faith Corcoran, 65

Gift of Rita M. Cushman in memory of George A. Rentschler, 59

Gift of the artist [Dehner], 208

Gift of Eric Denker and Wendy L. Livingston in honor of Anne-Imelda Radice, 124

Bequest of John N. and Dorothy C. Estabrook, 23

Gift of Alexander Cochran Ewing, 125

Gift of Mr. and Mrs. William Faulkner, 292

Gift of Susanna Levine Fisher, 226

Gift of Mrs. A. Grant Fordyce, 232

Gift of Mr. and Mrs. James E. Foster, 265

Gift of Joan B. Gaines, 132, 134, 135

Gift of the artist [Gut], 284

Given in memory of Muriel Gucker Hahn by her loving husband, William Frederick Hahn, Jr., 90

Gift of Mr. Gordon Hanes, 56

Gift of Helen Hayes, 150

Gift of Son San Hi, 306

Gift of Olga Hirshhorn, 239

Loan from Wallace and Wilhelmina Holladay, 18, 21, 33, 49, 57, 58, 87, 93, 97, 99, 112, 114, 116–17, 136, 139, 148, 149, 153, 154, 156, 160, 179, 188, 205, 206, 211, 215, 255, 280, 283, 298, 305, 307, 310

Purchased with funds donated by Wallace and Wilhelmina Holladay, 47

Gift of the Holladay Foundation, 130, 244

Gift of Caryl and Martin Horwitz, 152

Purchased with funds donated by Mr. and Mrs. William White Howells, 297

Gift of Caroline Rose Hunt, 231

Gift of the artist [Imboden], 303

Gift of the artist [Kim], 294

Gift of the artist [Larrabee], 200, 201

Gift of S. Tudor Leland, 106

Gift of Mr. and Mrs. Edward P. Levy, 227

Gift of Lioness Books (Vivien Leone), 256

Gift of Mark Luca, 174

Gift of the Honorable Clare Booth Luce, 184, 191

Gift of Edna Van McLeod, 175

Museum purchase: The Members' Acquisition Fund, 207, 304

Gift of Ann D. Michell, 285

Gift of Corinne Mitchell, 212

Gift of Cherie Mohrfeld, 115

Gift of Jeannette Montgomery, 196

Cosponsored by The National Museum of Women in the Arts and Pyramid Atlantic, 273–75

Gift of Minnie B. Odoroff, 262

Gift of the artist [Patterson], 172, 173

Gift of Chris Petteys, 26–27

Museum purchase: The Lois Pollard Price Acquisition Fund, 309

Gift of the Honorable John D. Rockefeller IV, 299

Gift of Robert F. Ryan, 254

Gift of Mrs. Walter S. Salant, 225

Purchased with funds donated by Lolo Sarnoff, 295

Gift of Diane Singer, 279

Gift of Elizabeth Sita, 95

Gift of Marion Hammett Smith, 217

Gift of Philip M. Stern, Washington, D.C., and Kristin Peterson, 289

Gift of Mary Ross Taylor in honor of her mother, W. B. Abbott, 272

Gift of the artist [Tenneson], 277

Gift of Lily Tomlin, 268

Gift of Catherine and Robert Tyrell and partial purchase by Members' Acquisition Fund, 113

Silver collection assembled by Nancy Valentine; purchased with funds donated by Mr. and Mrs. Oliver R. Grace and family, 64, 66–69, 71–81

Gift of the daughter of the artist [Weiss], 293

Given in honor of the artist [Welty] by Samuel Nelson Lefkowitz, Rose Helen Lefkowitz, Harry and Pauline Goldstein-Edelstein, Theodore and Pauline Morris Dattel, Louis and Anna Ray Cohen, Joseph and Molly Cafritz-Edelstein, and Harry and Pauline Edelstein, 168

Gift of Mrs. Philip D. Wiedel, 210

Gift of Richard York, 123

Gift of Helen Cumming Ziegler, 169, 170, 171, 197–99

Gift of Jacques S. Zinman, 151

# INDEX OF ILLUSTRATIONS

*Abandoned Cottage*
  (Berresford), 235
*Abandoned Doll, The*
  (Valadon), 146; detail, 118
Abbema, Louise, 112
Abbott, Berenice, 163–67
*Accession* (Hesse), 252
*Adelphi* (Hammond), 268
*Advancing Magic Squares*
  (Wiegand), 216
*Adventure at Sea, An* (Attie),
  270; detail, 271
Albee, Grace, 182
Albers, Anni, 238, 239
*Alligator Pears in a Basket*
  (O'Keeffe), 161
*Altar In Venice* (Redpath),
  224
Alvarez Bravo, Lola, 202
*America* (Carriera), 47
Anguissola, Sofonisba, 14,
  18
*Anna Pavlova* (Hoffman),
  176
Armond, Dale de, 300, 301
*Artist and Her Family at a
  Fourth of July Picnic,
  The* (Spencer), 90; detail, 91
*At the Flower Market*
  (Beard), 149
Attie, Dottie, 270, 271
*Audrey Flack Sketchbook*
  (Flack), 280
Aycock, Alice, 269
Baber, Alice, 232, 233
*Bacchus #3* (Kooning), 264
Bailly, Alice, 148

Baranek, Frida, 309
Barnard, Edward, 78–81
*Basuto Family, Lesotho, South
  Africa* (Larrabee), 200
Bateman, Ann, 71–73
Bateman, Hester, 70, 71
Bateman, Peter, 71–73
Bateman, William, 71, 73
*Bath, The* (the Cassatt), 102;
  detail, 103
*Bathing Hour* (Walter), 150
*Beach Scene* (Peterson),
  152
Beale, Mary, 23
Beard, Alice, 149
Beauclerk, Lady Diana, 56
Beaux, Cecilia, 98
Benedict, Enella, 95
*Benet* (Pepper), 289
Bentivoglio, Mirella, 267
Berresford, Virginia, 234,
  235
*Betty Parsons* (Abbott), 167
*Betty Sadler* (Dix), 135
Bishop, Isabel, 227
*Black and Brown* (Dehner),
  209
Blaine, Nell, 218
*Blue Still Life* (Shreve), 299
Bonheur, Rosa, 51
*Book in a Cage* (Gut), 284
Borchers, Karen T., 276
Bouguereau, Elizabeth
  Gardner, 94
*Bouquet of Flowers in an
  Empire Vase* (Valadon),
  145

Bourgeois, Louise, 206
Bouzonnet-Stella,
  Antoinette, 26–27
*Bowl of Lemons and
  Oranges on a Box of
  Wood Shavings and
  Pomegranates* (Moillon),
  21; detail, 17
*Boy with Red Hair* (Dix),
  134
*Breakfast of the Birds*
  (Münter), 158
*Bright Moonlight* (Weiss),
  293
*Brittany Children* (Benedict),
  95
Brownscombe, Jennie
  Augusta, 96, 97
*Burial, The* (Gikow), 226
*Burning Boundary* (Baber),
  232
Burrows, Alice, 74, 75
Burrows, George, II, 75
Bush-Brown, Margaret
  Lesley, 110
*Bust of a Girl with an Earring,
  A* (Kauffman), 52
*Bust of a Girl with a Rose in
  Her Hair, A* (Kauffman),
  53
Buttall, Sarah, 69
Byrne, Anne Frances, 88
*Café Terrace, Paris* (Tabary),
  212
*Cage, The* (Morisot), 100
*California Desert* (Dahl-
  Wolfe), 198

Call to Church and Flowers (Hunter), 254

Carriera, Rosalba, 47

Carrington, Leonora, 258, 259

Cassatt, Mary, 102–5

*Cerise, Olive, Turquoise Disks* (Riley), 242

Chapman, Minerva, 115

Chase, Louisa, 308

*Chauffeur* (Kohlmeyer), 222

*Cherries in the Sun (Siesta)* (Lee), 191

*Child with Ball* (Münter), 156

Cho, Young-ja, 306

*Church and Castle, Mont Saint Michel* (Clements), 111

Citron, Minna, 178

Claudel, Camille, 109

Clements, Gabrielle de Veaux, 111

*Coco Chanel* (Abbott), 166

Coe, Sue, 310

*Colette* (Dahl-Wolfe), 199

*Composition* (Kogan), 160

*Composition of Circles and Semicircles* (Taeuber-Arp), 189

*Concert, The* (Leyster), 33

*Copal #7* (Rockburne), 260

*Cosmic Universe* (Goncharova), 214

*Costume Design for "Les Equivoques d'Amour"* (Exter), 177

Courtauld, Louisa, 68

*Crookhey Hall* (Carrington), 259

Croswell, Mary Ann, 76

Cunningham, Imogen, 174

Dahl-Wolfe, Louise, 169–71, 196–99

*Dancing Lizard Couple* (Hanson), 283

Danzinger, Joan, 282

*Dawn's Wedding Feast* (Nevelson), 221

*December Irises* (Forrester), 298

*December Second* (Hartigan), 225

Dehner, Dorothy, 207–11

*Delaunay* (Schapiro), 273

*Delaunay, Goncharova, Popova and Me* (Schapiro), 273–75

Delaunay, Sonia, 186–88

*Dissertation in Insect Generations and Metamorphosis in Surinam* (Merian), 34–39

Dix, Eulabee, 133–35

*Djuna Barnes* (Abbott), 163

*Docks at Gloucester* (Peterson), 153

*Dr. VII* (Albers), 239

*Double Portrait of a Lady and Her Daughter* (Anguissola), 18; detail, 14

*Downtrodden, The* (Kollwitz), 140

*Earth, The* (Kim), 294

*Edna Saint Vincent Millay* (Abbott), 164

*Eggs* (Vidotto), 296

*Elevated Traffic over Moat and Bridge* (Jacquette), 307

Emes, Rebecca, 78–81

Emmet, Lydia Field, 125

*Empty Pods* (Kronzon), 295

*Entrance of Emperor Sigismund into Mantua, The* (Bouzonnet-Stella), 26–27

*Epic* (Godwin), 231

*Ethel Barrymore* (Dix), 133

*Ethel Page (Mrs. James Large)* (Beaux), 98

*Eva le Gallienne* (Abbott), 165

Exter, Alexandra, 177

*Fair Weather* (Berresford), 234

*Family of the Earl of Gower, The* (Kauffman), 54; detail, 42

*Fan, The* (Vonnoh), 129

*Farewell, The* (Kollwitz), 143

Feline, Magdalen, 67

Fini, Leonor, 205

*First State* (Gag), 179

Flack, Audrey, 248, 278–80

*Flowers in a Vase* (Ruysch), 40

Fontana, Lavinia, 19, 20

Forbes, Elizabeth A. Armstrong, 116–17

Forrester, Patricia Tobacco, 298

Frankenthaler, Helen, 245–47

Frishmuth, Harriet Whitney, 136

*From Generation to Generation* (Bravo), 202

Gag, Wanda, 179

*Gentleman's Table, A* (Hirst), 114

*George II Kettle on Stand* (Feline), 67

*George II Sauce Boat* (Mills and Sarbitt), 64

*George II Tea Caddy* (Godfrey), 66

*George III Child's Rattle* (Croswell), 76

*George III Double Beaker* (H. Bateman), 70

*George III Goblet* (A. Bateman and P. Bateman), 72

*George III Lemon Strainer* (Buttall), 69

*George III Snuff Box* (A. Burrows), 74

*George III Sugar Tongs* (H. Bateman, A. Bateman, and W. Bateman), 71

*George III Teapot* (A. Burrows and G. Burrows II), 75

*George III Teapot Stand* (Northcote), 75

*George III Tea Set* (A. Bateman, P. Bateman, and W. Bateman), 73

*George III Tea Set* (Langlands), 77

*George IV Silver-Mounted Two-Handled Coconut Cup* (Emes and Barnard), 81

Gérard, Marguerite, 63

Gikow, Ruth, 226

*Girl on a Small Wall* (Valadon), 147

Godfrey, Elizabeth, 65, 66

Godwin, Judith, 231

*Goncharova* (Schapiro), 274

Goncharova, Natalya Sergeevna, 214

Gonzalès, Eva, 99

Goodwin, Betty, 305

*Great Gold Pan, The* (Aycock), 269

*Green Calash, The* (Hale), 124

Grigoriadis, Mary, 262

Grossman, Nancy, 256

*Growing Up, Coming Out* (Borchers), 276

Gut, Elisabetta, 284

Hale, Ellen Day, 122–24

Hallam, Beverly, 297

Hammond, Harmony, 268

*Hannah: Who She Is* (Flack), 278

Hanson, Ann, 283

Hartigan, Grace, 225

Haudebourt-Lescot, Antoinette-Cecile, 87

*Head of an Old Peasant Woman* (Modersohn-Becker), 139

Hepworth, Barbara, 230

Hesse, Eva, 252, 253

Hirst, Claude Raguet, 114

Höch, Hannah, 215

Hoffman, Malvina, 176

*Holy Family with Saint Elizabeth and Saint John the Baptist, The* (Sirani), 24

*Holy Family with Saint John* (Fontana), 20

*Honeysuckle, Poppies, etc.* (Byrne), 88

Hunter, Clementine, 254

Huntington, Anna Vaughn Hyatt, 127

Imboden, Connie, 303

*Indian, Indio, Indigenous* (Smith), 304

*In Front of a Red Sunset* (Höch), 215

*Iris, Tulips, Jonquils, and Crocuses* (Thomas), 240; detail, 192

Jacquette, Yvonne, 307

*Jar, Acoma Pueblo, New Mexico* (Lewis), 290; detail, 291

*Jar, San Ildefonso Pueblo, New Mexico* (Martinez), 181

*Jar, Santa Clara Pueblo, New Mexico* (Tafoya), 229

*Jardin de Luxembourg VII* (Kooning), 265

Jessup, Georgia Mills, 213

John, Gwen, 154, 155

*June* (Hale), 112, 122

Kahlo, Frida, 184, 185

Käsebier, Gertrude, 130, 132

*Kathy* (Tenneson), 277

Kauffman, Angelica, 42, 52–54

Kim, Soo Ja, 294

King, Jessie Marion, 137

King, Marcia Gygli, 292

Kogan, Nina, 160

Kogelnik, Kiki, 257

Kohlmeyer, Ida, 222, 286, 287

Kollwitz, Käthe, 140–43

Kooning, Elaine de, 264, 265

Krasner, Lee, 219

Kronzon, Ziva, 295

Labille-Guiard, Adélaïde, 57

*Ladder II* (Dehner), 210

*Lady in an Evening Dress (Renée)* (Perry), 108

*Lady with a Bowl of Violets* (Perry), 109

*Lake at Bois de Boulogne* (Morisot), 101

*Lake Spirit* (Armond), 300

Langlands, Dorothy, 77

*Laning at Work* (Citron), 178

Larrabee, Constance Stuart, 200, 201

Laserstein, Lotte, 180

*Lauren Bacall in Helena Rubinstein's Bathroom* (Dahl-Wolfe), 171

Laurencin, Marie, 203

Lee, Doris, 190, 191

Lewis, Lucy M., 290, 291

Leyster, Judith, 33

*Lilies* (Hale), 123

Lisiewska-Therbusch, Anna Dorothea, 49

Loir, Marianne, 48

Longman, Evelyn Beatrice, 126

*Looking North F* (Dehner), 208

*Love in Bondage* (Beauclerk), 56

*Love's Young Dream* (Brownscombe), 96

*Madeleine de la Bigotière de Perchambault* (Mercier), 50; detail, 45

*Magic Witch, The* (Carrington), 258

*Magnolia Blossom* (Papplendam), 175

*Manger, The* (Käsebier), 130

*Manhattan Backwash* (Albee), 182

*Marengo* (Roberts), 281

*Marigolds* (Robbins), 93

Martin, Agnes, 228

Martinez, Maria Montoya, 181

*Mary Jane Russell in Dior Dress* (Dahl-Wolfe), 197

*Maxwell Anderson with Walter Houston* (Dahl-Wolfe), 170

*Mechano/Flower Fan* (Schapiro), 272

*Men and Girls Walking* (Bishop), 227

Mercier, Charlotte, 45, 50, 51

Merian, Maria Sibylla, 34–39

*Merryn* (Hepworth), 230

*Merz Sonata, A* (Weier), 285

*Millicent Rogers* (Dahl-Wolfe), 196

Mills, Dorothy, 64

Mitchell, Joan, 266

Modersohn-Becker, Paula, 138, 139

Moillon, Louise, 17, 21

*Monsieur de Solticoff* (Vigée-Lebrun), 60

Morgan, Gertrude, 255

Morisot, Berthe, 100, 101

*Mother and Child* (Nuñez del Prado), 223

*Mother Louise Nursing Her Child* (Cassatt), 104

Mott, Laura, 113

*Mountain Family at Supper* (Patterson), 173

Münter, Gabriele, 156–58

*Nancy Aertsen* (Peale), 86

Navarre, Marie-Geneviève, 55

Neel, Alice, 183

*Nevada* (Roberson), 302

Nevelson, Louise, 221

Northcote, Hannah, 75

*Nude Doing Her Hair* (Valadon), 144

*Nude Reclining* (Zorach), 162

Nuñez del Prado, Marina, 223

O'Keeffe, Georgia, 161

*Oliver le Gouidic de Troyon* (Mercier), 51

*Ophelia, Nashville* (Dahl-Wolfe), 169

*Orion* (Thomas), 241

*Ozymandias* (Danzinger), 282

*Pair of George II Sauce Boats* (Godfrey), 65

*Pair of George III Tea Caddies* (Courtauld), 68

*Paperweight* (Hallam), 297

Papplendam, Laura Van, 175

Parsons, Betty, 263

Patterson, M. Marvin Breckinridge, 172, 173

Peale, Anna Claypoole, 86

Peeters, Clara, 32

*Peggy (Portrait of Margaret French)* (Longman), 126

Pepper, Beverly, 289

Perry, Lilla Cabot, 106–8

*Persian Steep* (Grigoriadis), 262

Peterson, Jane, 152, 153

*Playdays* (Frishmuth), 136

Ponti (Frankenthaler), 247

Popova (Schapiro), 275

*Portrait of a Girl in a Hat* (Laurencin), 203

*Portrait of a Noblewoman* (Fontana), 19

*Portrait of a Woman in White* (Gonzalès), 99

*Portrait of a Woman with a Black Hood* (Beale), 23

*Portrait of a Young Boy* (Vigée-Lebrun), 62

*Portrait of a Young Girl with a Blue Ribbon* (Abbema), 112

*Portrait of a Young Woman* (Navarre), 55

*Portrait of Elsa Tudor* (Perry), 106

*Portrait of Eulabee Dix* (Käsebier), 132

*Portrait of Jesse Dorr Luca* (Cunningham), 174

*Portrait of Madame Louise Vigée* (Romany), 58

*Portrait of Mrs. Stuart* (Mott), 113

*Portrait of Princess Belozersky* (Vigée-Lebrun), 59; detail, 2

*Portrait of Thomas Ewing III* (Emmet), 125

*Portrait Sketch of Mme. Fontveille, No. 1* (Cassatt), 105

*Prayer for the Dead* (Gikow), 226

*Prelude to a Concert* (Gérard), 63

*Presumed Portrait of Madame Geoffrin* (Loir), 48

*Presumed Portrait of the Marquise de Lafayette* (Labille-Guiard), 57

*Princess Catherine Chikovskoy* (Vigée-Lebrun), 61

*Quartered* (Kohlmeyer), 287

*Rainy Night Downtown* (Jessup), 213

*Raven Made Women* (Armond), 301

*Red, Turquoise, Grey, and Black Bands* (Riley), 243

Redpath, Anne, 224

*Regency Argyll* (Emes and Barnard), 78

*Regency Goblet* (Emes and Barnard), 79

*Regency Parcel-Gilt Mug* (Emes and Barnard), 80

*Rest in His Hands* (Kollwitz), 142

Riley, Bridget, 242, 243

Robbins, Ellen, 93

Roberson, Pamela, 302

Roberts, Priscilla, 281

Rockburne, Dorothea, 260, 261

*Rolls Royce Lady* (Flack), 279; detail, 248

Romany, Adèle, 58

*Rose, The* (Watson-Schütze), 131

*Roses, Convolvulus, Poppies, and Other Flowers in an Urn on a Stone Ledge* (Ruysch), 41; detail, 28

Ruysch, Rachel, 28, 40, 41

Sage, Kay, 204

Saint Eberle, Abastenia, 128

*Sale Neige* (Mitchell), 266

*Sanctuary* (Dehner), 211

Sarbitt, Thomas, 64

Schapiro, Miriam, 272–75

Schurman, Anna Maria Van, 22

*Seated Woman* (John), 155

*Self-Portrait* (Bailly), 148

*Self-Portrait* (Kollwitz), 141

*Self-Portrait* (Schurman), 22

*Self-Portrait Dedicated to Leon Trotsky* (Kahlo), 184; detail, 185

*Sheba* (Rockburne), 261

*Sheep by the Sea* (Bonheur), 92; detail, 82

*Shepherd David Triumphant, The* (Bouguereau), 94

*Shoot* (Yamaguchi), 288

Shreve, Anne, 299

Sirani, Elisabetta, 24, 25

*Sister Gertrude Morgan* (Morgan), 255

*Sitting Female Nude* (Modersohn-Becker), 138

*Sketchbook Comprising Thirty-eight Portrait Drawings of Women and Children of the Russian Court* (Vigée-Lebrun), 60, 61

Smith, Jaune Quick-to-See, 304

Spencer, Lilly Martin, 89–91

*Spiritualist* (Frankenthaler), 246

*Spring Diary* (Grossman), 256

*Springs, The* (Krasner), 219

*Staffelsee in Autumn* (Münter), 157

*Still Life: A Shelf in the Studio* (Chapman), 115
*Still Life of Fish and Cat* (Peters), 32
*Still Life with Watermelon, Pears, and Grapes* (Spencer), 89
*Storm Series II* (King), 292
*Study for Portugal* (Delaunay), 186–87
*Study for Sculpture* (Hesse), 253
*Study of a Woman in Mulberry Dress* (John), 154
*Summer and Winter* (King), 137
*Summer Dryad* (Truitt), 244
*Summer Sunlight* (Van Ness), 159
*Supenwoman* (Kogelnik), 257
*Symbols* (Kohlmeyer), 286
Tabary, Celine M., 212
Taeuber-Arp, Sophie, 189
Tafoya, Margaret, 229
Tanning, Dorothea, 236, 237
*T.B., Harlem* (Neel), 183
*Telegram, Detention Room, Ellis Island, The* (Walter), 151
Tenneson, Joyce, 277
*Thanksgiving at Plymouth* (Brownscombe), 97
*Thank You America (Anita Hill)* (Coe), 310
Thomas, Alma, 192, 240, 241
*To Malherbe* (Bentivoglio), 267

*To Max Ernst* (Tanning), 236; detail, 237
*Tomorrow, for Example* (Sage), 204
*Town, The* (Vieira da Silva), 220
*Traute Washing* (Laserstein), 180
*Troubadours* (Blaine), 218
Truitt, Anne, 244
*Untitled* (Albers), 238
*Untitled* (Baranek), 309
*Untitled* (Bourgeois), 206
*Untitled* (Chase), 308
*Untitled* (Cho), 306
*Untitled* (Dehner), 207
*Untitled* (Delaunay), 188
*Untitled* (Fini), 205
*Untitled* (Flack), 280
*Untitled* (Frankenthaler), 245
*Untitled* (Goodwin), 305
*Untitled* (Imboden), 303
*Untitled* (Lee), 190
*Untitled* (Saint Eberle), 128
*Untitled (Cat in Window)* (Wiegand), 217
Valadon, Suzanne, 118, 144–47
Van Ness, Beatrice Whitney, 159
Vidotto, Elena Bonafonte, 296
Vieira da Silva, Maria Elena, 220
Vigée-Lebrun, Elisabeth-Louise, 2, 59–62
*Virgin and Child* (Sirani), 25

Vonnoh, Bessie Potter, 129
*Wall #2, The* (Martin), 228
Walter, Martha, 150, 151
Watson-Schütze, Eva, 131
Weier, Debra, 285
Weiss, Lee, 293
Welty, Eudora, 168
*White Column* (Nevelson), 221
Wiegand, Charmion Von, 216, 217
*Will-o'-the-Wisp* (Forbes), 116–17
*Winged Frog* (Parsons), 263
*Witwatersrand Goldminer Watching Sunday Mine Dance, Johannesburg, South Africa* (Larrabee), 201
*Woman Fishing in the Canal* (Bush-Brown), 110
*Woman of the Thirties, Hinds County, A* (Welty), 168
*Woman Shelling Corn* (Patterson), 172
*Woman with a Veil* (Lisiewska-Therbusch), 49
Yamaguchi, Yuriko, 288
*Yawning Panther* (Huntington), 127
*Young Girl with a Sheaf* (Claudel), 109
*Young Woman Seated in the Shade of a Tree* (Haudebourt-Lescot), 87
Zorach, Marguerite Thompson, 162